Notes on Post-Conceptual Poetry

Felix Bernstein

Preface by Trisha Low

**INSERT
BLANC
PRESS**

Los Angeles, CA

NOTES ON POST-CONCEPTUAL POETRY
© Felix Bernstein
Insert Blanc Press 2015
ISBN: 978-0-9961696-3-9

Cover image © Lawrence Schwartzwald, no reuse without permission.

Parts of this work were published previously in *The Believer, Fanzine, Lemon Hound, The Awl, The Volta,* and *Hyperallergic.*

Table of Contents

Not that the avant-garde ever really meant revolution. Only the journalism about it takes it to mean that—takes it to mean a break with the past, a new start, and all that. The avant-garde's principal reason for being is, on the contrary, to maintain continuity: continuity of standards of quality—the standards, if you please, of the Old Masters.

—Clement Greenberg

You Guys, We Need to Talk About Felix

Preface by Trisha Low

You guys, we need to talk about Felix.

And I don't mean like in the that 2011 movie *We Need to Talk about Kevin*, starring Tilda Swinton, where she gets knocked up by the devil in a sea of mushed up tomatoes at some made-up Italian festival or whatever. Cause as it turns out, Tilda Swinton's kid isn't really the antichrist, or even some kind of low-level ghoul or demon. Boringly, like every smart kid who goes to high school, he just wants to kill everybody—and eventually he does—not with a gun, but with a bow and arrow because predictably, there's nothing supernatural about him, even if he wishes he were special. He's just another acne-ridden RPG world-building nerd, you know, "hackers"?

Like Kevin, Felix Bernstein is not the antichrist either, even though people like to act like he is. Felix is not even anything like Kevin. He doesn't play video games and to date, he has not yet become a serial murderer. In fact, the only similarity between Kevin and Felix Bernstein is that they both have to contend with existing inherited realities. For Kevin, this is the fact that he was an unwanted child, and possibly conceived by the union of his mother and the devil. For Felix, this is the reality of being avant-royalty. Born to one notable poet, Charles Bernstein, and one notable artist, Susan Bee, Felix was intended to be our Prince Charming, set to inherit the kingdom. But surely, even Prince Charming is allowed his teenage years, the years during which, as Bataille writes, "intimacy cannot be expressed

discursively. The swelling to the bursting point, the malice that breaks out with clenching teeth and weeps; the sinking feeling that doesn't know where it comes from or what it's about; the fear that sings its head off in the dark; the white-eyed pallor, the sweet sadness, the rage and the vomiting ... are so many evasions." Evasion is a quality of adolescence, an interstitial channel for unconscionable rage, which is also the only available and conceivable mode of reaction for both Kevin and Felix.

Kevin's rage is simple and uncritical, resulting in simple massacre. But Felix is smarter, and his rage is milder and slightly more impotent? It basically just comes out as this kind of thing where he spits out the life that his parents gave him as an ineffectively shrill squandering of privilege. Anyway, we need to talk about Felix, so I'll just tell you now that maybe the best way to approach this introduction is probably to take it extremely seriously. A boy and his mental health is at stake. I mean, think about it more like an episode of *Intervention* because let's face it: the first step is to make Felix admit that he has a problem. Right? Cause otherwise the level of embarrassment that *Notes on Post-Conceptual Poetry* elicits for him, and more importantly for us, would probably become too much for us to bear.

Born into a family of cultural importance and poetic nobility, Felix Bernstein's future was glowing. Like a Machiavellian prince, Felix has inherited not only his name but also the authority to prescribe value and attribute to our little lives, both aesthetic and actual, their lost meanings. And as such an ennobling authority, Felix does just this in a contradictory pronouncement of power. *Notes on Post-Conceptual Poetry* is basically a circle-of-life generational takedown of an older vanguard, asserting the aesthetic of a "new generation" in a tract that is more like a meat market carnage of unnecessarily heavy philosophy, bitchy contemporary critique, and Freudian couch confession. Subjects who suffer Felix's careless allotment of value, both his high praise and damning refusal are forced to pitch themselves sideways between whether their work has *more meaning, no more meaning,* or maybe more importantly meaning only if you're affiliated with the LUMA Foundation's 89. Or if you have a tumblr

with a ton of net art affiliated followers or have ever sucked Kenny Goldsmith's dick (yrs truly included). Like as in most sovereignties though, in this exchange of value, the subjects of "study" in this flippantly and self-indulgently heavy-handed critique are nothing but constituent parts of Felix's own self—they *become* the little prince. Or at least like Antoine de Saint-Exupery's Little Prince, everyone's potential to be spared by Felix and live, or to be sent to the axeman and die, is also his potential for both. To nepotistically thrive, or to die dick-deep in complicity. How embarrassing for everyone.

So that sounds like a problem, right, and yeah, sure, we need to talk about Felix. But actually here's the other thing—for all the shit we can give him, Felix is unquestionably a very funny human, a very funny performer. It is very entertaining, or at least I find it to be very entertaining to sit in an audience and watch him make noises and drag multiple identities in a very reasonable amount of makeup. But the most embarrassing thing about Felix is not very funny at all. As it turns out, the most embarrassing thing in any of this nonsense is that Felix is in fact a psychotic homicidal maniac kamikazi-ing the plane we've all strapped ourselves in, for better or for worse, into a mass grave. How could this ever happen? Could we ever make such a monster? Whoops, I guess so. No, we cannot make sense of why it happened. We don't know if anyone ever will. We don't know if we will ever be whole again. We don't know if we will go a day without pain. We don't know if anything will ever make sense again. I mean, lol.

Here's the thing: our now ubiquitous dialogue of democratic poet discourse and artistic economy really deeply disturbs Felix. I mean, maybe Felix is just another Machiavellian prince with privileged rainbows spewing from his pores, and so has a deep hatred for most of humanity. But when I think about it Felix just has a really deep hatred for artists. As he writes to me "but what is a poet? and why is their body so sacredly untouchable by public consumption? and really: what the fuck is a poet!?"

Notes on Post-Conceptual Poetry creates a resistance to the world model that he, that we artists and critics and fucking poet-critics are so immersed in simply by saying, as Dylan Klebold and Eric Harris did after the 1999 Columbine school shooting, that DEAD PEOPLE DON'T ARGUE. Despite *Notes'* endless fouetté turns of accusation, negative capability and détournment, it essentially remains an Occam's Razor in that everybody dies in the slaughter, Felix included. And his princely civility in allotting value betrays a greater, natural incivility of despotism, one that actively submits to and obeys the law and in the process turns out in a primordial effulgence of life, death, growth and decay that acknowledges no laws or bounds of saving face—a crime scene. And it doesn't stop there. Like the best of CSIs, Felix isn't so much distorting as applying the role of photographic representation to a social and aesthetic milieu, reproducing images in order to find an arrangement of corpses (paradoxically) in the integrity of the discourse itself. The resulting body conceptual (the body of conceptualism) can suddenly be interminably manipulated. In Felix's hands, conceptualism, the body, is transposable to any homologous geometry. Each of its polemics, each of its practical deformities becomes a potent metaphor for the excitements of a new sadistic, reflective violence, the text itself easily parsed by its own condemnations of narcissism. A thing we should never forget: generation X is just a transmutation of space, the problems fucking carry.

Which is to say that Felix's homicidal audacity is not the hotness of youth, but a kind of cool detached anality, that of the mortician, a peculiar and inhuman grace. He's designed all that death as a social experiment so he can isolate and study its results in a little glass Petri dish. In all of his videos too, there's a similarly catalogable, similarly elaborate profile of multiple wounds, but who cares? Felix definitely doesn't because even though his staging is a sort of neo-Sadean, post-camp grammar of showgirl excess, his characters are really only *rehearsing* accident positions—they study and represent bodily postures of crisis without fully enacting them. Felix's work is a massacre because it exhausts—its successes continually, paradoxically traced in its open intimations of its limits, always depositing something unmentionable by the wayside and by wayside I really mean in your face. Piledriving

into its own auto-erotic shit, it leaves its stain at the edges of our knowledge, but not softly. With a fucking Hi-Point model 995 *carbine rifle*. Not subtle, not cute. Ultimately, *Notes on Post-Conceptual Poetry* does not pitch itself as either a martyr or convict's lament—rather a continual transgression of a threshold of self-becoming that seems central to the development of the next generation of the avant or whatever, even while it's, or at least Felix is trying (and failing) to define himself. I mean, itself. Rather, its constant performative re-positioning of his self-identity in relation to every institution makes for a pretty successful squandering of his princely privilege, or at least a very good Lifetime movie.

But maybe like Mrs. Klebold I am allowed the memory of washing dishes while Felix watches intently, telling me about his latest project or how to keep up with Grindr or someone he is sleeping with. Same thing, really. Maybe I am allowed the memory of his writing me something I am already thinking but did not know the way in which I was thinking it, in an email when he says "but this ultimate passivity is exhausting because its borders must be continually redrawn against the sadistic Other. Of course, you know this as a masochist. I think it is something we have in common." Felix's work is simply a medium that allows an extra limitation of itself at the exact moment at which it's interpreted in a completely literal way by a psychotic subject. And suddenly, at that moment, it is uncertain if Felix is coming for us or if we are in fact, coming for his princely little head.

Notes on Post-Conceptual Poetry

Deluxe Edition

With thanks to Cassie Seltman, Nellie Barber, and Herman Rappaport, for reading and discussing. And thanks to Gabe Rubin for talking me off the ledge.

Identity resides within group-thought, group-belief, group-fashion. It is to be found in fads, sects, and subcultures. Its uniforms, accoutrements, and accessories can be purchased over the counter because they are mass produced. Uniqueness plays no role in identity nor could it. Uniqueness, by its very nature, is its utter antithesis. So where exactly is the place where identity and individuality intersect and overlap? Don't bother to look for it, because it doesn't exist, except as an abstraction in the minds of those who desire both and possess neither.

—Boyd Rice

Remember *me* but forget my fate.

—Dido, *The Aeneid*

Introduction

<u>What is post-conceptual poetry?</u>

Post-conceptual poetry is nothing more than a term that means generationally following and reacting to conceptual poetry, often in dialogue with the earlier genre. Some even call post-conceptual poetry 'second-generation conceptual poetry,' as Kenneth Goldsmith and Rob Fitterman taught many post-conceptual poets directly or indirectly.[1] Post-conceptual poetry, by virtue of following conceptual poetry, also follows postmodernism (which at least by virtue of the Norton *Postmodern American Poetry* anthology can be thought to contain Language poetry) and is therefore post-postmodernism.

However, contra Fredric Jameson, postmodernism is better thought to refer to the empty simulacrum art and culture of the '80s and Language poetry is more accurately poststructuralist.[2]

<u>Isn't conceptual poetry post-conceptualism?</u>

Yes. Conceptual poetry, by virtue of following '80s postmodern art (Pictures Generation: Cindy Sherman, Sherrie Levine), is post-postmodern; by virtue of following '70s poststructuralist poetry (Language poetry) is post-poststructuralist; by virtue of following '60s conceptualism (Fluxus, minimalism) is post-conceptualism. Of course, as one can tell from its billing, conceptual poetry is not merely attempting to follow conceptual art (and therefore to align with all that is post-con-

ceptualism, which can include '80s postmodern art and '70s post-structuralist poetry) but also to repeat it, and has successfully created some rather purely retro conceptual procedures. It has also aligned itself quite strongly with '80s postmodernism and the empty simulacrum. Both the '80s and '60s can be marked by their aesthetics of empty and vapid indeterminacy — with that emptiness being valorized for being Zen (Marcus Boon on Kenneth Goldsmith or John Cage on John Cage) or for being ironic, funny, and reflexive of the culture at large (Baudrillardian celebrations of '80s art found in the art journal *October*). Language poetry, deconstruction, historicism, and poststructuralism, all coming of age in the '70s, attempted a rigorous negative dialectical poetics of the sometimes mechanistic, sometimes arbitrary, but always playful, fancy/imaginary (as opposed to a fixed God-given monarchical classical old fashioned Coleridgean imagination). Poetic fancy was largely abandoned by the project of conceptual poetry (although some of its mechanistic and arbitrary features were appropriated), as well as by the overarching attempts to follow up postmodernism with a post-postmodernism that redoubles the emptiness of postmodernism and revokes the insights of rigorous poststructuralism by returning to structuralism.

What is post-conceptual poetry, again?

Post-conceptual poetry, by virtue of following conceptual poetry, can be seen as inaugurating a new tide in the post-postmodernisms (such as conceptual poetry) that came of age in the '90s and early '00s. Its practitioners, born (on average) in the mid-'80s, are part of a larger trend within post-postmodernism to bridge affect, queerness, ego, lyric, and self-conscious narcissism within the inherited procedural structures of the 'network' and the 'concept.' They are therefore part of a larger turn to queer structuralism that aligns the dry, empty hierarchies of structuralism (to which post-postmodernism has unanimously returned) with the abjection that the term 'queer' allegedly refers to.

Who are the post-conceptual poets?

Some post-conceptual poets are Sophia Le Fraga, Andrew Durbin, J. Gordon Faylor, Trisha Low, Josef Kaplan, Kate Durbin, Joey Yearous-Algozin, Holly Melgard, Danny Snelson, Steve McLaughlin, and Steve Zultanski. Of course, each has a relation to other aesthetic lineages, some clear examples being Le Fraga's relation to performance art, Low's relation to the Chris Kraus/Kathy Acker memoir,

Clockwise left to right: Andrew Durbin; Sophia Le Fraga and Trisha Low; Steve Zultanski; Gaga Stigmata (Book Cover)

Andrew's relation to camp and New York School poetry, Kate's relation to the gurlesque. Some poets older than the ones mentioned also are expanding the field of post-conceptual work: Brian Kim Stefans who is generationally in line with flarf and conceptual poetry but seems to be a nascent developer of post-conceptual style. But don't get the wrong idea: I'm not trying to fill quotas so this can be a nice canon for the academy, nor am I trying to keep up with the in-crowd, make friends, or call any one mentioned here genius, revolutionary, Marxist, or unprecedented. I'll leave that to Daniel Tiffany.[3]

The famous cousins of post-conceptual poetry are Lady Gaga (b. 1986) and Ryan Trecartin (b. 1981). Their work responds to similar pressures in their given fields. I like to call post-conceptual poets and their colleagues in other fields queer conceptualists and/or queer structuralists because of their desire for particular micro-communities/queerness combined with a fear of abandoning the jargon of conceptual art as an apparatus of the social network and the academy.[4] There are some other ties: Goldsmith (b. 1960) has promoted Trecartin numerous times, and Gaga shares Goldsmith's worship of Warhol. Gaga has been an important buzzword for queer theory vis-à-vis Judith Jack Halberstam's "Gaga feminism" and also for L.A. post-conceptual poet Kate Durbin's blog Gaga Stigmata. Finally, Trecartin has been discussed alongside Goldsmith in *Artforum* and *Art in America*.

Can the post-conceptual poet do anything new?

Not always.

Post-conceptual poets can assert authorship by claiming that the 'author is dead' (à la perverse postmodernism/poststructuralism: Language poetry and Flarf) thereby slipping into the schizopoetic vulgar muck of the Internet.

Post-conceptual poets can assert authorship by claiming that the 'text is dead' (à la post-poststructuralism/post-postmodernism: conceptual poetry) thereby deferring to conceptual, algorithmic, appropriative mastery over the muck of schizopoetic textual flows.

Post-conceptual poets can assert authorship by deferring to the confessional/affective/lyrical (traditional, Romantic poetics) or the mechanical/conceptual or, better yet, they can mix both together (as a conceptual strategy or as a heartfelt impulse or some hybrid of both).[5]

None of that is new. However, the post-conceptual poet can do one new thing and declare the 'death of work' (unprecedented by its immediate poetic lineage, though common with the madness poetics of Artaud and esteemed by Foucault and Deleuze). This is symmetrical to the 'death of the reader,' which means here, the death of the close, analytic, or aesthetically discriminate reader. This would mean falling into the messy muck of libidinal flows (or the Internet or 'whatever') without leaving a trace of authorship and without giving in to those dominant modes of leftist discourse (that mark the academy, the art world, and politics), which require the artwork to pave the way for didactic redemption, and require that art be boxed into the framings of queer theory or speculative materialism[6] or poststructuralism or affect studies or Badiousian-Žižekian, etc.[7] That is to say that the post-conceptual poet could make works that are not afforded privilege of 'example' in the seemingly endless war between 'neoliberal versus subversive' or 'subjective/affective versus mechanical' or the various attempts to wield both subject and object (micro and macro) together vis-à-vis universalized particulars like the term 'queer' (which has recourse both to a conceptual universalized apparatus and a particular, affective, minority).

So, perhaps post-conceptual poetry can de-cathect from the strategies of didactic redemption and/or didactic counter-redemption that mark the marketing strategies that have created the canons of conceptualism and post-conceptualism, Language poetry and conceptual poetry, in the first place. Then, what will occur is a madness that signals not the disappearance of the author [Language poetry], or the disappearance of the text [conceptual poetry], but the final disappearance of work itself.

Alas: no more work for the consumption of others, for the didactic pronouncement of amoral or moral causes, for the inevitable redemp-

tion of the market. But also an end to the predetermined paths meant to demonstrate madness and perform 'no work' but have therefore become work, examples, and formulas (such as the tired formula "an excess of work = no work," which has been put to very good use by conceptual poetry).

Unfortunately, the 'death of work' (or 'the death of the reader') seems as likely to occur *in full* as the death of the author or the death of the textual ever did. That is because of the need in post-conceptual poetry (as was true of Language poetry, and conceptual poetry) for redemption, branding, and formulaic notions of politics, differential marks, hierarchies, and didactic declarations. However, 'the death of work' does not need to occur 'in full' to remain paradigmatic of the constellation of practices known as 'post-conceptual poetry.' And by death of the work, I mean that coupled to the death of the writerly and readerly that came with conceptual poetry's death of the textual, there is furthermore a death of any recourse to an informed thinkership (such as the one Goldsmith appeals to): however this does not necessarily mean an end to the curatorial, hierarchical, performative, gestural, theatrical, designerly, fashionable, cool, cliquish: what it does mean is a less informed set of readers who are not even readers, thus I call it: 'the death of the reader.' Moreover, the set of practices employed by the post-conceptual workers, if they are to be called workers with a set of practices at all, are either so frivolous that one can outright dismiss them as having no work ethic, no ethics, no work, no practice; or else, their work is so exhaustively inclusive that it reorganizes the boundaries that separate work from play, art from life, and therefore trap the art in a place it cannot be seen at all (that is to say, there is little to no 'separating gesture' that will grant the work any esteem or canon value the way Dadaists would have for blurring boundaries between life and art, rather this is an invisible blurring).

Has post-conceptual poetry been redeemed and valorized yet?

Yes. The assertion of didactic modes of redemption for the newly post-conceptual poets are budding, primarily in and through discourses around the visual arts in publications that attempt to sell art-

works by making a claim to a work's radicality. These notes will pull apart some of the more flagrant attempts that have been made to use pre-existing stale discourses (such as queer theory, affect studies, and Marxist theory) to promote the work of these artists and poets. But it will also look at the ways in which conceptual poetry and Language poetry have been either redeemed or condemned by critics (as well as the poet-practitioners themselves).[8]

Are these notes a work of post-conceptual poetry?

As might become quite obvious, these notes enact a kind of push-pull between pathetic confession, ironic self-criticality, advanced complicity, enraged hostility, information surplus, gossip, and longing (for an end to work) that is characteristic of post-conceptual poetry (and youth). Still, I do try here to somewhat maturely take interest in history (over and against theoretical sophistry and my own likes and dislikes), an interest that has been seriously absent in the attempts, by many critics and poets, to deal with issues similar to those discussed in these notes. The forgetting of history will perhaps allow these critics and poets to take pride of place in the canon formations that will mark this moment. And that is sooo neoliberal—or is it subversive? I can't tell anymore....

Notes on Post-Conceptual Poetry

Hans-Ulrich Obrist. Photo by Yang Fudong, (Shanghai), 2009.

1) Everyone can be a poet but only one person gets to amalgamate all that poetry and present it to the larger institutional world of art, endowing it with value. This time, that person is Kenneth Goldsmith working with Hans-Ulrich Obrist.

2) Mary Kelly made it so that we can raise a baby in a museum. Now Goldsmith has enabled us to stage our postpostpostrevolts in the museum. And forge tons of minor, counter-canons under the auspices of a singular private-collection-cum-web-domain (ubu.com).

3) These notes were possibly rejected as possible data for Goldsmith and Obrist to amalgamate for their world-wide-web-renowned event "Poetry Will Be Made By All." These notes will not be published online at poetrywillbemadebyall.ch and published at the LUMA/Westbau exhibition space within Löwenbräukunst in Zurich, Switzerland.[9] This is not one of 1,000 books published under the condition that the author be born in or after 1989 and asked by one of the

appointed advisors to the project. These notes will then not tour the globe and be collected by those collectors who are interested in the work of Goldsmith and/or Obrist. They did not receive recognition from Obrist in the *LA Times* for being fun, fabulous, and hip. However, Insert Blanc Press, a harbinger of post-conceptual content, has published these notes, that are in your hands, with a blurb by post-conceptual curator J. Gordon Faylor and other markers of being 'embraced.' Despite receiving an early praise from a Canadian critic for being a 'Fuck You' to the hip world of art and poetry, it was met warmly by most everyone. Except some of my friends who said: why didn't you go harder. Paradoxically, these notes bonded me to Vanessa Place but it might have made things precarious with Goldsmith, who did tweet a link to an early incarnation but has a different canon to be thinking about (keeping up with the kids, as he must: alt-lit and whatever else makes it to the top of 4Chan and Reddit, his world-renowned tweets reading like: "Dude, the printing press is so cool, twitter is so cool, Pepsi is cool, alt lit is cool, the avant-garde is so cool, modernism is so cool! Dude, Perloff is so cool, Napster is so cool! Dude! Please, listen: School is cool! Learning is hip! Captain Beefheart is cool! I'm cool! Please! Listen to me! I'm cool! You still there dude? Wake up man, dude, bro, buddy! Notice how cool art stuff is with me! I'm lonely, dude."). As for Hans, he has his eyes set on a different prize, Instagram and the poems of Andrew Durbin, both of which he recently praised in the *LA Times*.

4) I am filled with hope that this counter-canon formation will position me as the next amalgamator of data and that I will one day be king of the canon. However, since I deride curating anyway, at the very least, I hope this will position me as a critic who can discern whatever new talents will emerge from the muck of Internet art, and follow in the wake of Goldsmith and associates, who have pro forma outstayed their welcome [i.e., planned obsolescence: this is the Now, it will expire soon then KG].

5) If you are having trouble coming up with new ideas just repeat your old ideas but Skype them in to Zurich. Their value will multiply.

6) Even better say this: "If you are having trouble coming up with new ideas just repeat your old ideas but Skype them in to Zurich. Their value will multiply." But say it while Skyping in to Zurich.

7) I hope that these notes will be Skyped to Zurich. (They won't be.) I hope that these notes are shared on Goldsmith's Twitter. (They might be.) *Odi et Amo.*

8) We are all masters of Tumblr and Facebook but only some of us are good enough at using Tumblr and Facebook that we can receive institutional recognition and be written up by Claire Bishop (b. 1971) or Kareem Estefan. Digital art is a huge mess where everyone is a star and everything is disseminated. But only one or two leaders disseminate things (information, and press releases, if not goods) well enough that they can also receive art world recognition. Thus Bishop's *Artforum* essay "Digital Divide" praises Goldsmith (conceptual poetry), Cory Arcangel (straight net aesthetics), and Ryan Trecartin (gay net aesthetics)[10]–all of which she finds hallmarks of her position, a return to critique and negation over and against happy relational aesthetics.

9) With the Internet anything can be brought into the poem, anyone can become a star, and the dictates of fashion (receiving likes) replace the critic's authority. And yet the crisis that all of these critics (from the older rock star to Hal Foster) seem to be bemoaning when they cannot figure out who determines talent on the Internet is really a crisis that at the same time is the most wonderful thing ever for the critic. Because the greater the *mise en abyme*, the more important the role of the critic to make order. And therefore, most critics writing in glossy magazines bemoaning the *mise en abyme* of fashion are purposefully negligent of the fashionable luxury they gain from this *mise en abyme*: the critics' (and curators') importance is redoubled! And most, of course, take the chance when bemoaning this *mise en abyme* to emphasize those few artists they feel are exempt from this charge. [This may be one of my approaches in these notes.]

10) Estefan praises Trecartin in *Art in America* for complicating hardcore conceptualism à la Goldsmith[11] (though, more recently, Estefan

has written that he finds in Trecartin's new work a naïve acceptance of cyborg post-humanism troublingly akin to neoliberal solutionism[12]. But Estefan's essays, appearing as they do in the pages of hip and corporate magazines, mimic the very neoliberalism he ascribes, as a slap in the face to some of the artists he judges. Therefore it can seem that when it was more in vogue for him to do so, he put forward Trecartin as a post-conceptual hero and when not, not. Trecartin, like Goldsmith or Lady Gaga—or anyone else—can be used as a cipher for critics to claim "she is neoliberal" or "she is subversive" ... ad nauseum. See the endless blog wars about Beyoncé or Miley. But I would be blatantly parodying my own argument by saying "it is the blog posts and the hip art critical discourses that are *really* neoliberal." No, I'd rather not appeal to morality. I'll just say: Criticism of the kind offered by Estefan or Jeffrey Nealon or Christopher Glazek (not to mention your average queer blogger) is not intellectually rigorous enough and is severely limited by only being able to look at work that plays within the irony/affect divide. Such criticism is deathly afraid of work that slips beyond this overdetermined critical playing field. Moreover, rather than having any objective way to assess what is or is not neoliberal, such criticism relies on what is liked or disliked, usually letting opportunistic fancy lead the way. Not that there's anything wrong with opportunistic fancy! But let's be honest: The will to power has not vanished in queer hip cool art historical discourse and there is not, and will never be, some transparent inclusive queer-friendly criteria for art criticism.

11) Estefan's original appraisal of gay male artist Trecartin in *Art in America* was that he showed a way to loosen the constricting straps of conceptualism à la Goldsmith. But to be fair, Goldsmith's work is 'born' post-conceptual (coming decades after the height of conceptualism) and does show interest in affect and queerness. His own involvement in the catalog for the Institute for Contemporary Art's 2010 show *Queer Voice*, which included Trecartin's work, attests to this—not to mention his interest in the gay male artist Andy Warhol (b. 1928), who was a genius at combining dull structuralist mechanic techniques with affective bodily queer subcultural trippy punk romantic colorfulness. Nonetheless, the critical trend is to discuss

Goldsmith's work as a kind of white straight man's conceptualism, while Place (b. 1968) or Trecartin are viewed as taking the conceptual straitjacket and subverting it by dealing with queer themes.

12) The problem is not that there is too much muck out there but that there isn't enough, not enough muck to overwhelm the function of the critic. Or to make the critic admit that at least a major part of their job is to employ opportunistic sophistry.

13) So many daring critics have attempted to rescue messy postwar poetics from its *mise en abyme*. Think of what happened after Fredric Jameson (b. 1934) described Language poetry as empty neoliberal drivel.[13] George Hartley redeemed the work for being meaningful both politically and aesthetically. Barrett Watten's O'Hara performs ideological critique, Michael Davidson's Spicer performs ideological critique, Keston Sutherland's Wieners performs ideological critique, Jeffrey Robinson's post-romantic fanciful postmodern poets (whom he defends against the Coleridgean complaint of their being mechanistically fanciful) perform ideological critique.

14) Then, also, there is the attempt to redeem works for their affective ordinariness: Adam Fitzgerald's Charles Bernstein, Jeffrey Nealon's Kenneth Goldsmith, and Andrew Ross's Frank O'Hara.

Charles Bernstein and Bruce Andrews. Photo by John Tranter, 1991. Courtesy of photographer.

15) The danger is plunging into the abyss of complicity (as Johanna Drucker has detailed); an abyss that post-conceptual poetry flirts with to the point of, at times, nearing its own extinction.[14] My father, Charles Bernstein (b. 1950), a founding Language poet, wrote, "My humor is so dark you can't see it," but this line was nonetheless 'seen' (and became one of a group of his quotes that are used as a refrain in so many

Marjorie Perloff. Photo by Emma Bee Bernstein, 2007.

academic book intros). Post-conceptual poetry potentiates the possibility of understanding this joke but not telling it. Of fading fully 'back to black.'

16) Here is a sharp Marxist argument that should be made repeatedly: "We all can put out our music for free but Madonna or Gaga or Beyoncé will be the top-selling touring artist. Private property is a thing of the past. Except for houses and money. Those must remain distributed in the same old way." This critique can and should be leveled against the rhetoric of conceptual poetry (founded in the 2000s) and Gaga feminism (founded in the 2010s) and queer theory (founded in the 1990s).

17) Beyoncé is neoliberal. Beyoncé is subversive. Beyoncé is neoliberal. Beyoncé is subversive. Beyoncé is neoliberal. Beyoncé is subversive. Beyoncé is neoliberal. Beyoncé is subversive. Beyoncé is neoliberal. Beyoncé is subversive. Beyoncé is neoliberal. Beyoncé is subversive. Beyoncé is neoliberal. Beyoncé is subversive. Beyoncé is neoliberal. Beyoncé is subversive. Beyoncé is neoliberal. Beyoncé is subversive. Beyoncé is neoliberal. Beyoncé is subversive. Beyoncé is neoliberal. Beyoncé is subversive. Beyoncé is neoliberal. Beyoncé is subversive. Beyoncé is neoliberal. Beyoncé is subversive. Beyoncé is neoliberal. Beyoncé is subversive. Beyoncé is neoliberal. Beyoncé is subversive.

Beyoncé is neoliberal. Beyoncé is subversive. Beyoncé is neoliberal. Beyoncé is subversive. Beyoncé is neoliberal. Beyoncé is subversive.

18) When attempting to resolve whether or not Beyoncé is neoliberal or subversive, bloggers usually deny the way in which they valorize their own powers of discriminatory judgment. The more specific, non-moral, critical judgments of a critic sans identity politics like Marjorie Perloff (b. 1931) never will forget its own discriminatory judgment. The judgments are therefore lampooned as being elitist.

19) So, perhaps in fear of looking like an elitist asshole, many contemporary curators and professors instruct and critique as if their own fancies did not come into play. This only redoubles their elitism and makes them more difficult to call out. On the left, there is a moral judgment; on the right, there is a golden standard of craft.

20) Goldsmith, above all else, valorizes a certain craft and technique. His critical champions, above all else, valorize moral judgment. Therefore he appeases left and right.

21) Then there are those who attempt explicitly to refuse moral judgment or even the dictates of craft and technique. Instead, you ought to rely on master discourses and formulas that outwit the dumb ego that produces art and critique. This is what Žižek (b. 1949) does (via a kind of theoretical Stalinism) and what Place does (via a kind of Žižekianism).

22) Sharing on Facebook, curating an art show, and writing a hip dissertation all operate in a similar way: Find a private, specific, marginal bubble (a disturbing punctum) and bring it to the public marketplace.

23) Kids these days: Tumblring new styles, bandcamping new genres, wikipediaing new paradigms. Goldsmith is a kid, opening up as many tabs as he possibly can. Kids these days are able to utopianize the dystopia, re-photograph their multiple tabs, and compete with each other as to who can more uniquely capture the punctum of our trivial existence. (Don't worry. It's just a game.)

24) Obama is a kid these days. He can use the binary framework of like/dislike to his best advantage and get the most followers and the most likes/comments/views.

25) Facebook was built to stalk girls and now from the youngest age we make ourselves stalkable, turning our children's baby books into pornos; then they grow up to turn their teenage traumas into stylish books, their everyday hobby/life into a work resume.

26) To reiterate the introduction: these notes are partially about post-conceptualism broadly construed: art that follows both the post-modern visual art conceptualism of the '60s and the poststructuralist poetics of Language poetry in 1970s. This includes the visual artists of the Pictures Generation in the 1980s and the conceptual poetry of the early 2000s (both of which returned to many of the tenets of conceptual art).

Post-conceptualism is one of many post-postmodern discourses (in general, those who are post-postmodernism and anti-postmodernism are also anti-poststructuralism and post-poststructuralism).

Note here that Language poetry is poststructuralist but it is not really 'postmodern,' as it is commonly used to refer to the empty, meaning-less, schizophrenic signifiers of '80s visual art, Baudrillard's simula-crum, and MTV. However, this is how Jameson viewed the work of Language poet Bob Perelman. And indeed, it is as likely to be thrown out with arguments against postmodernism offered by those like Žižek and Badiou who fault postmodernism and poststructuralism alike for its splintered identity categories, its emphasis on ordinary language, seductive ideological framings, complicity, and linguistic determinism. Language poetry certainly shared some characteristics with '80s postmodernism. However, it had much more in common with the *poststructuralist* theories of libidinal flow popularized in the late '60s and early '70s (as part of, among other things, the sexual revolution). In this way, if it was 'postmodern,' it was a kind of shad-ow side of postmodernism. It can also be seen as part of a cross-sec-tion of events (happening in the Bay Area and downtown New York

culture) that included feminist and gay avant-garde and proto-punk performance art. This '70s are well illustrated by Jay Sanders' *Rituals of Rented Island* at the Whitney Museum of American Art (Fall 2013), which included work by Richard Foreman and Jack Smith. This world was much different from what would come about under Reagonomics and the Pictures Generation in the art world's 1980s, which can more properly be called 'postmodern' and often joins itself at the hip with Baudrillard's simulacrum theory. As *Semiotext(e)* editor Sylvère Lotringer has written of his own work in the '70s (his notorious 'Schizo-culture' conference and journal), it "was about living in New York, in which I saw French theory's wildest extrapolations realized, or at least mine. Being in New York until the early 1980s was like living in theory, madness included."[15] Sanders elaborates, "Lotringer began to imagine a materialist semiotics that rejected language altogether and instead sought a language of objects themselves. Turning fortuitously to the visual arts, he immersed himself in the performances of Jack Smith, Foreman, Sherman, and others seeing this radical potential imbedded implicitly in their work...."[16]

27) If poststructuralist political radicalism climaxed in the mid-'70s, (while aesthetically only coming into academic, and de-politicized, prominence in the '80s), then post-postmodernism reflects the various attempts to follow the act. Post-postmodern discourses (Goldsmith, Geoffrey Harman, Katerina Kolozova, François Laruelle, Lee Edelman, Claire Bishop, José Muñoz) have attempted to move beyond negative dialectical materialism, phenomenological humanism, being-in-language, radical skepticism/relativism, and splintered micro-politics in order to enact a discourse centered around universalized particulars such as the term 'queer' or the counterhegemonic Marxist 'revolutionary.' The universalizing of particulars has meant that the micro political emphasis on 'affect' has been projected into a larger field of 'affect studies' and communal attachments full of jargon and didactic structure that are praised for granting access to 'heterogenous peoples.' Post-postmodernism, particularly its attempt to universalize 'difference,' is largely influenced by Žižek and Alain Badiou (b. 1937), in their use of Lacan's matheme as a way to approach the real without having to go through the splintered identi-

ties of poststructuralism. But post-postmodernism is split down the middle, with some following the Baudrillard of the 1980s who describes the disappearance of the real altogether (conceptual poetry) and others following François Laruelle (affect studies, queer theory, speculative materialism), who insists on a non-discursive real; however, they do not employ visionary romantic tactics to realize this real but rely instead on jargon and proscriptive formalism. Nonetheless, both end up bringing something real yet discursively encoded to the table. Deadpans like Goldsmith and Baudrillard are obsessed with punctums that will appeal to the human spectator, just as much as queer theory does. Conceptual poetry has little to do with the hippie spirit that marks conceptual art of the '60s, as chronicled by Lucy Lippard and made famous by the term Fluxus.[17] Its origins are in the 1980s art world.

28) In distinction to conceptual poetry, which aligns happily with Baudrillard's deadpan disappearance of the real, post-conceptual poetry attempts to explicitly bring affect, emotion, and ego back into the empty networking structures that govern us. For many, this is a resounding relief.

29) Post-postmodernism seems on paper to be about giving oneself over totally to the machine and the symbolic (conceptual poetry) and the object and the real (affect studies, speculative materialism) with no human self-reflexive phenomenological imaginary. Nonetheless, the emerging double 'post' remains haunted by the same human value-oriented, patriarchal, hierarchical scaffoldings as its predecessors. Yes, it makes sense that people are eager to leave behind the subjective correlationist phenomenological lyrical neurotic egotistical fantastical imaginary postmodernism of the late '60s and early '70s. But it is becoming alarmingly clear that none of the discourses that followed postmodernism have been able to abandon the ego. In fact, they merely redouble the naïvely (unself-conscious) human will to power. As usual, this will to power is consistently redoubled at any point where it seems to have disappeared. So, it appears that post-postmodernism is all about merging with the machine or the real with only a glimmer of irony/framing/aestheticism. And it appears

that post-postmodernism has fulfilled the death drive of dark and negative dialectical thought by completely erasing the manifest image of humans. But how can we forget that it is always egos performing that erasure for the 'impartial' critic whom it tries to woo?

30) Some post-conceptual poets might admit the melancholic impotence of the desire to abandon the human in favor of the real (affect) and the symbolic (technology) and give up this escapism mid-concept (whereas most conceptualists never admit their pathos). Nonetheless, the post-conceptual poet must keep attempting to add exhaustion to the content of the work. If one actually abandons the machinery of Facebook and Twitter and networking and queeronormative identities one is cut out of the archive altogether. That is to say, only happy dandies (they can be exhausted, queer, or crippled as long as they are 'happy') can and do succeed in this economy.

> Indeed it gets better: even if you are trans and anorexic and dying of terminal illness and bullied, just keep on posting about it and you'll be accepted!! Heaven is a place on earth. Don't wait for the judgment of God. Find and embrace the judgments of your queer community.

31) Queer-conceptualism, broadly construed, should be a clean mathematical process akin to algorithmically adding excess to structure; nothing should appear to be done by hand or by breath because the value here comes from the robot that seems like a human. (The human that seems like a robot as a motif has been exhausted by postmodernism.)

32) Just being weird and messy does not ensure canonization as post-conceptual poetry unless the work directly pushes against conceptual parameters.

33) The post-conceptual poet cliché: Make frivolous mention of social media, celebrities, art world institutions, or offer a jargoned feminist/queer theory critique of those institutions, and hope to get validation merely from the use of buzzwords. Or, in a slightly more self-critical

variation on the theme: Make fun of yourself for being limited by these buzzwords and discourses but refuse to take a stab at doing anything else.

34) In 1975 a turn against the splintered discourses of Freudian-Marxist poststructuralism (epitomized by the open economy of Bataille and the sexual politics of Marcuse) brought in a period of sober restoration led by those who wanted to amend the schizopoetic into a tidy healing discourse (such as Deleuze, who became the go-to French theorist of the 1990s) or those who wanted to valorize universalized counterhegemonic activities (the resolutely anti-postmodern Badiou and later Žižek, both following the formalistic Lacan, not to mention Mao and Hegel, rather than the chaotic nonsensical Lacan), thus inspiring those who preferred a universalized particular identity in the '90s (queer theory). This war was waged against the splintered identities (determined wholly by their linguistic signification) of chaotic poststructuralism. Conceptual poetry follows up on this move, finding ways to patch together (through appropriation) the various messy slave discourses that were inaugurated by postmodern poetics.

35) Those who grew up to be post-conceptual poets are those who missed the protopunk anarchy of the '70s and the revolutionary politics of the late '60s. Rather they were born in the '80s, during the deadening Reagonomic period in art (the Pictures Generation and later, in Britain, the Young British Artists) in which previously political postmodern tactics were frozen into monumentally valorized works of blank irony with global celebrities at the wheel. Then they came of age during the '90s, a time when Riot Grrrl feminism and Deleuze (minor literature spawning micropolitcs and microcinemas) and Judith Butler's subversion and queer theory and Žižek's Hegelian

Judith Butler, 2014. Copyright European Graduate School.

Marxism became prominent. And then they started working in the '00s: finding ways to combine the empty symbolic art of the '80s with the 'subversive' affective cyborg-utopian feminist tactics of the '90s. This post-conceptual combo meant letting go of the splintered punk and separatist politics found in the late '60s within hippie culture, but also in Lower East Side art culture. Suddenly, in the '00s, punk seemed as romantically insular and individualistically hedonistic and complacent as modernism and romanticism looked to the radicals of the 1970s. Nonetheless, it was compelling and it felt good to be punk! So in order to maintain this 'good feeling,' punk became permissible only through and after neurotic apologies and academic dissertations and ironic quotations. And in order to maintain the political potential of punk, its movements were reformulated into a universally applicable (rather than individualistic) party-politics-for-all, epitomized by the universalized particular and academically 'counterhegemonic' emblem marked by the word 'queer.'

Queerness created the possibility of rallying around a shared 'disgust' and 'apathy' and 'alienation' and 'negativity,' thereby erasing the particular untranslatable difficulties of the individual's

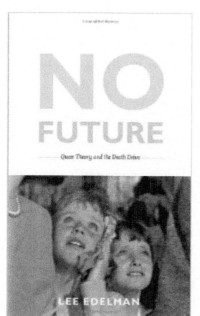

personal visionary experience of displeasure and easing us into a kind of harmonized 'punkness'-without-hostility. The void of 'no future' that had led in the past to suicidal visionary anarchy became an academic and refined communitarian identity through the maneuverings of queer professors such as Lee Edelman (b. 1951, queer structuralist/queer conceptualist). But this can also be seen in non-philosophers such as the feminist non-philosopher Katerina Kolozova (b. 1969), who is pissed that postmodernism/poststructuralism (particularly

the kind represented by Butler's 1990 classic *Gender Trouble*) has meant that we never have access to the real in and of itself but only through the bars of language's prison house (like Language poetry: Charles Bernstein's "Only the imaginary is real"). Nonetheless, Kolozova claims that using the obtuse and scientific jargon of non-philosophy (invented by François Laruelle) can finally grant us access to a real 'real,' not just a real couched in irony: killing off the tyranny of negative dialectical

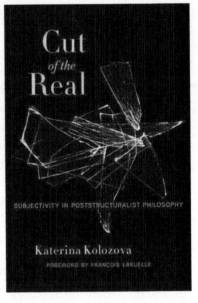

skepticism that has never given us bodies that matter or an outside world that we could trust as real. Thus, Kolozova has found a way to wed non-philosophy, feminism, and queer theory together in a post-postmodern (post-poststructuralist) queer structuralism/queer conceptualism (a re-structuralism) that allows the real (here marked QUEER) to be found through objective, scientific criteria. And this has not gone unnoticed. Her star is only beginning to rise, and recently a prominent queer theory journal has devoted an issue to non-philosophy, at least in part because of her endeavors.

This sort of access to the 'real' would have been impossible in most major works of poststructuralism or postmodernism (from Jacques Derrida and Bruce Andrews to Baudrillard to Sherrie Levine). One would never 'stupidly' give in to symbolic communitarian identities. And even poststructuralist postmodernism (particularly in its Jewish varieties) recognized a certain possibility for a future disclosure of the real; still, the real never really came. Yet this same blank, unfulfilled void, which caused so much negative, agnostic 'waiting' in postmodernism has since been filled by joyous notions of political cathexis and fidelity: Badiou (simultaneously writing alongside the postmodernists but an active critic) being the post-postmodernist most heav-

ily committed to the idea of structurally determined 'indeterminate' hyper-contingent events. Yet the speculative materialists, particularly Quentin Meillassoux (b. 1967) also privilege this hyper-chaotic contingency as being a place for radical rupture (basically, a site for God), as do the queer structuralists and non-philosophers.[18] Fidelity to this grand event and all the Hegelian determinism that it implies is the genesis of these new identities. This, however, has much in common with Hegelian structuralism in general. Look at the journal *October*, where, as per the title, subjectivity (or at least, recognized subjectivity) is determined by some sort of grandiose fidelity to the Russian October Revolution. Place, a brilliant re-structuralist, maneuvers the splintered discourses of the 'slave' and the 'victim' and turns them into monumental, cool artworks.

36) Place would be a post-conceptual poet if she did not so belligerently cross out the imaginary, the ego, ideological framings, material play, etc. But she is able to do quite a bit within conceptualism. She is able to bring an oozingly affective, unabbreviated real (the testimonies of rape victims) through a materialistic ego-based creative space (the imaginary) that is nonetheless crossed out (in favor of appropriation, allegory, irony) and into the symbolic order (that is, cool, avant-garde, self-conscious, cutting edge, masterful poetry). The difference between her and post-conceptual poets will be that the post-conceptual poet will not necessarily cross out the imaginary (just as Flarf never did). Therefore, there might be in the work of some post-conceptual poets a return to negative dialectical play with framings and confession. It should also be noted that Place was once a post-conceptual poet (her novel *La Medusa* reflects this) but then became 'conceptual,' at least in part because conceptual poetry has a more reliably distinguishable canon.

37) Post-postmodernists, broadly conceived, ignore the ego. They would rather key in on affective residues (the analytic third that exists between analyst and analysand) rather than the analysand's ego and their own will to power in co-creating the framing mechanisms that pass as 'neutral' within a given discursive framework.

38) Place is very good at framing and traditional authorship (see her astute and convincing book *The Guilt Project*) and is merely trolling by shoving all her court cases at us. This type of trolling is so common in our culture that to many it seems unremarkable. However, my response is coming from someone born in 1992 and perhaps my boredom with trolling is generational. Yes, it might make one question what is and isn't a book, etc. But what's so funny about her project is that for all her claims of presenting the thing without moral markers, she is nonetheless overtly didactic about the apolitical moral position she chooses. Maybe the problem with party politics isn't that they are 'moral' but that they are didactic and lack vision. If so, then her amorality shares in that same problem.

39) Place praises Perloff for recognizing poetry as a thing and not a moral instrument, despite the fact that Perloff has long been a huge advocate of ruthless discrimination, radical collage, and radical artifice, as opposed to the sort of amoral thing that Place gives us. Nonetheless, when the amoral thing becomes chewed up and spit out as art mastery, as occurs in Place's case, then it can properly claim the aesthetic attention of a historical and formalist critic like Perloff.

40) The art dubbed 'institutional critique' was always good for pointing out the exclusive limitations that governed the museum and its relations to collectors. But institutional critique had to remain a polished craft that had esteemed practitioners. Now that everyone can be an artist and big museums look toward the Internet and small galleries and microcinemas, there is a sudden free-for-all, and, as Hal Foster has lamented, a loss of consensus. People who put forward institutional critique are embarrassed. Benjamin Buchloh (b. 1941) writes, "A new generation of artists claimed the legacies of Duchamp and Warhol without so much as an atom of the transgressive and subversive intelligence that these two putative forbears had historically initiated." (Of

Benjamin Buchloh. Photo by T.J. Kirkpatrick/Harvard News Office.

course, he's always had problems with the more mainstream among the neo-avant-garde since the '80s but his complaints have crescendoed.) And so the October journalists must seek out a new genius, who will show hostility towards the mise en abyme of the galleries without erasing the tenets of dry institutional critique. So Buchloh can turn to Andrea Fraser (b. 1965). Younger queerer critics might, for similar reasons, turn to K8 Hardy (b. 1977), an artist who demands to be seen as quasi-post-conceptual because she does not show the heroic mastery of ideological structures that someone like Fraser (or Place, for that matter) does. Yet Fraser and Place will endure, in part due to a need to preserve an aristocratic elite of institutional critique in art, even though both are interested in parodying and lobotomizing this mode as they are repeating it.

41) To argue on discriminatory aesthetic grounds with Perloff's appraisal, it is perhaps altogether mistaken to attribute so much power of invention to Goldsmith. In poetry, perhaps, he has had the most radical newness (in responding to the drivel of post-Language poetics). However, in the context of the visual arts (and here is where he cashes in), where Warhol is already a mandatory example, he looks like just another proponent of the repetition of Warhol's formal tactics (a pop Duchampianism that has also already been absorbed into pop culture)—just as, in poetry, Place's inventions seem quite new and profound (in responding to the drivel of male-dominated cool conceptual poetry). However, in the visual arts, the deadpan quasi-feminist repetitions of Warhol (in which a female artist repeats his strategies but intrudes upon them with redoubled Lacan-inflected affect) have been done to death (and, sorry Place, but female artists doing Warhol to death, while knowing that what they are doing has been done to death, has also already been done to death).

42) I am not saying that Goldsmith merely copies Warhol's formal method of appropriation. More importantly, he also convinces us (as Warhol did) of a lurking lovely genius behind the façade. This is more than many amateurish Warhol copycats do. Nonetheless, in this, he has missed out on what could have been his crucial invention: throwing away the need to convince us of the 'lovely genius.' That would

be the great risk! In all, Goldsmith has proven to be too conservative and too respectful of Warhol's legacy. Doing so has won him many advantages: It has allowed him entrance into pop culture and the art world, since Warhol's legacy is still sanctimoniously worshipped. And, therefore, he has gained quite a bit (of attention) but lost quite a bit (of invention).

43) So how have we gone about choosing our next geniuses (and this will be most crucial for the post-conceptual poets)?

- Firstly: Make randomly chosen artists using the Internet a part of consistent art historical lineage (so that the last room of the Metropolitan Museum of Art's *After Warhol* show featured Cory Arcangel and Ryan Trecartin).
- Secondly: Start websites like riverofthe.net or ubu.com that can mimic the mode of tube sites, which give us an overflowing of materials that, like tube sites, generate interest and income only to those at the very top.
- Thirdly: Turn to old-school critics like Buchloh and Perloff who will lambaste the mediocrity of contemporary democratic culture and therefore point to you as being a cut above the rest or somehow 'in on the joke' of the *mise en abyme* in the same way that earlier avant-gardists had been.

44) Buchloh: "Artists can continue to 'subvert' norms (emphasizing the latest trend) but are still mirroring the powers they are subservient too."[19] Duh. I mean, its fairly obvious from any theoretically acute perspective that things like James Franco's participation in the art world are not COMMUNIST or even aesthetically radical, nor is there anything particularly groundbreaking when a young gay dandy like Ryan McNamara predictably says, "Performance is inherently subversive in that the presenting institution cannot guarantee what's gonna happen." At least Goldsmith admits that saying things like "Everyone is a poet" is not about being subversive, that being subversive died out with the '70s. His project is not political. It is funny, though. Anyway, how is Buchloh (a key art world tastemaker employed by *Artforum* and

other publications to make it easier for buyers and museums to know what is 'good') any less mimetic of capitalism?

45) Nonetheless, people like Bishop, who writes with all the swish of someone proposing politically and aesthetically radical (and even 'negative'!!) perspectives, praise Goldsmith in utter sincerity as being of uber-importance in challenging visual art. The fact that his poetry can be valorized for 'challenging visual art' in an editorial in *Artforum* points to a paradox that can at the very least be mentioned by someone as astute as Bishop. Isn't the poetry that is illegible or unnoticed by the visual art world, that cannot be accepted in galleries and museums, posing more of a challenge to the stale hierarchies of visual art? I guess, to be a poet who gets a mention in *Artforum*, you can't just make work that poses a challenge to the hierarchies of visual art. It has to also participate in them. Damn.

46) Christopher Glazek on Trecartin in *n+1* (the hip, youthful, more 'oppositional' version of *The New Yorker*): "*Any Ever* depicts a universe with women in charge and gays as assistants. It is an exciting, glorious place and a sneak preview of what's to come. Art bros, beware: the future does not belong to you. Your generosity will not be exalted; your hijinks will not be adored; your slickness will not be humored. Grab a personality and buy a jumpsuit—the world is about to get more interesting."[20]

47) Re: Glazek: It's fine if you want to overthrow patriarchal hierarchies with a new feminist hierarchy where gay men are 'paid assistants.' But at least point to the fact that Trecartin is, in so many ways, the sole artist credited for his work. His collaborators (both tweens and women, particularly Lizzie Fitch) are not in charge. He is quite obviously a rich white male. And the article praising him is being written by a posh white male. I don't mean to suggest that white males making millions from art is a problem that needs to be addressed in every piece of art criticism about rich white male artists. But to ignore this fact in an article that is written under the guise of some sort of queer theory political agenda is bad journalism, bad politics, bad aesthetics, and bad scholarship. Which is to say (and this is prob-

ably the only thing you need to take from these notes), that *for all the emphasis on 'critique' and 'contextual awareness,' in the last instance, most who participate in critical discourses and art discourses persistently refuse to check their own context.*

P.S. I mean I know he writes about the prison industrial complex, mostly, but then he also writes stuff in *Artforum* praising the radicality of Lana Del Ray. I mean give me a break. And also why am I not published in *n + 1* or *Artforum?* I don't think I am more arrogant than you dear reader. I'm just choosing to show it here. As Ida Lupino says in *The Big Knife*, "From time to time, I believe in being completely senseless. I'm a woman, not a diplomat." And on that note, mark my words, one day *n + 1* will beg me to write for them the way they ran kicking and screaming to Daddy Žižek to get him to toss off a poorly scribbled Lacanian reading of the hipster.

48) Re: Artfrum.com: Recent critiques of the *mise en abyme* of Internet art proposed in this vaguely counter-art world art world imprint have maintained a glossy fixation on the industry that produces interest in what it critiques. Moreover, these critics delight in their own powers of discrimination and do not take into account the ways in which it is the valorization of the critic's discrimination that leads to the sort of art world of one percenters they loathe. The suggestion offered—it's time we look at things that aren't dominant in the art world and online—is quaint and on many levels opposed to the interest of the critic who wants to have a legacy within those systems. Moreover, for the most part, the art critic wants to simply replace what is most successful with something more marginal. And since artists rise to the top rather quickly, revolts happen very quickly. Keith J. Varadi's recent article "The Bubble Gum Dirge" ends by suggesting those on the sidelines need to do more work.[21] This point is acritical and ahistorical and typical of the blindsided indulgence of art world calls to arms. It feels foolish to have to say it, but, of course, those on the sidelines do plenty of work; it is terribly hard to break into the art world and not everyone wants to (or should). Does the fact that someone did not 'make it' in the art world say something about their merit as an artist or the amount of 'labor' that they put into their

art? After dragging the major trends of postconceptualism through the dirt (namely Gaga and millionaire Internet artists), Varadi nonetheless valorizes a select few who 'do it better,' on the way to saying that some 'other' undefined constellation of artistic practices should now take dominance because we are 'bored' by the ones currently in power. If you can start to get used to this formula, then you're on your way to being an art world critic.

49) Excuse me for offering, for just a moment, a 'closer reading' of Varadi's piece.

Firstly, let's question the location of the critique—a sly and flashy Tumblr called artfrum.com—and that he then makes several exceptions without really explaining why. For instance, he says that the work of Andrew Durbin is an exception; I think Durbin's work is very good and worth critical reflection, but I would have a hard time understanding how or in what ways it is distinct from the other work Varadi is talking about, and Varadi does not make the effort to elaborate on this distinction—which leads me to believe this might be an opportunistic reference. After all, Varadi's accompanying pictures tell a different story, a picture of Durbin drinking a Four Loko while reading is reduced anyway via its juxtaposition; it is simply one of many pictures of art that he refers to as cultural detritus. In the text, it seems the only way that Durbin is hailed to be 'different than the rest' is because he has "updated the Baudelairean dandy." This comparison is either ill-informed or poorly crafted bullshit. Baudelaire's dandy was a reaction against the tides of democratic culture, and quite clearly was marked tonally by depersonalized introversion. On the contrary, what is compelling about Durbin is his enthusiastic extroverted complicity with democratic and popular culture. Moreover, this is what is compelling about the figures of pop culture that Varadi condemns, who, as has been documented for years, most famously through and around issues of postmodernism, Madonna, and feminism, are aware of the problematics of complicity and are not the empty-headed twerps Varadi makes them out to be. This mistake is continued due to a kind of dogmatic slumber in Chris Kraus' blurb to Durbin's poetry book, *Mature Themes*, which claims, that the work is 'negative' (i.e., critical)

and Tan Lin's blurb that calls him the new Baudelaire. While this is made possible by virtue of some extreme Baudrillardian extrapolation, if one does not give some sort of specific evidence then the use of 'negative' might as well be applicable to absolutely any product of the culture industry. This was Baudrillard's problem too: he claimed negativity and the real had disappeared but he was all too in love with his own negativity, and the realness of the winking ironic cultural figures that arbitrarily met his fancies. Kraus seems to fall into this trap too, especially with her praising of Bernadette Corporation. It just seems trivial and out of whack with her otherwise consistent aesthetic position (to favor Simone Weil and Hannah Wilke over Cindy Sherman). Of course, it's fine to like anything no matter how much it lacks coherent criticality! Who cares? You can like Hentai octopus porn and McDonald's smoothies. I do! I'm not better than you. But on this issue and maybe a few others, I might be right. Unless it's wrong to take ad lingo far too seriously and then to be disappointed by the gap between the fantasy of radicalism, democracy, and genius and the reality of material inequality, racial or cliquish hierarchy, and stupidity. In a way, my diagnosis of myself is that I'm a sucker (who won't suck): I really want the ad to be real, I really want to believe! But when push comes to shove, I catch the gap, and I don't suck.

It should be emphasized that Baudelaire is a complex figure in regards to capitalism. As Hal Foster has pointed out, Baudelaire carved out the double status of the avant-garde perhaps more hysterically than any artist before or since with his quotable lines: "'I say 'Long live the revolution!' as I would 'Long live destruction! Long live penance! Long live chastisement! Long live death!' I would be happy not only as victim; it would not displease me to play the hangman as well—so as to feel the revolution from both sides! All of us have the republican spirit in our blood as we have syphilis in our bones; we have a democratic and syphilitic infection." And yet even with these complexities, his perspective was much 'darker' than the Warholian and especially the post-Warholian gay campy pop perspective, which arguably has a compulsory fun and celebratory aspect absent in Baudelaire.

Thirdly, let's question the authenticity of his critique. Those who truly disdain Internet art as much as Varadi claims would not so eagerly fold their critique up into the nexus of the very same discourse and modes of transmission of that artwork without at least making mention of the fact they were doing so. Moreover, has he talked to any artists not interested in being in the art world or in the poetry world about things like Internet art? There you will find a critique that is far more incisive because, for all its paranoid disinterestedness, it has a certain intelligence lacking here. None of them merely say "I don't like that form of art," they say "I don't like that whole discourse, that whole scene, I don't like those people, I don't like that structure, that debate, that hierarchy, that way of living life." Therefore, they don't even want to debate things, they don't want to inflame the scandal, they don't trust the eruption of another form, even if it would benefit them or their friends.

Lastly, let's question Varadi's intentions in making this critique, a critique that so obviously inflames the very sort of art discourses he claims to be 'critiquing'? I urge you to view the piece and to decide for yourself why he is making this critique. I honestly have no idea. I also urge you to track down other articles that condemn Internet art and count how many make an exception for a particular Internet artist. Then try and figure out who that Internet artist is in relation to that critic (a friend, a student, a powerful person, an academic colleague, an already canonized figure?). And really try and find out, do these people not like Internet art or do they just want their art and/or journalism to get more attention? Moreover, do these people really not like the apparatus of the art world or the poetry world, or do they like it but just want more status in it? It's tricky but it's fun, you should go do it! You can also do this for the Romantics, Futurists, Language poets, or whatever art clique you'd like to investigate! Do it with this piece! I would make a list of instances I've found recently, but that would be difficult to do without severely alienating myself from those critics whom, quite honestly, I would love to hear mention my name in the conversation around Internet art, in say the forthcoming collection of canonical essays on Internet art edited by Ed Halter due out from MIT Press. Wouldn't you like to hear your name mentioned?

50) Conceptual poetry takes far more—in its strategy if not its surface styles—from the visual art collective "Art and Language" and from the Pictures Generation artists than from Language poetry, which was markedly at odds with these art world approaches. Conceptual poetry rejects Language poetry's negative dialectical materialism and, rather, utilizes Art and Language's and Picture Generation's relational, dialogical, community-based, exchanges of commodities created through the collaborative valorizing of cliques. There, the coterie that forms valorization was a part of the work, forming an allegory for the notion that context determines content.

§Language poetry: inventive poetry (mundane networking): The death of the author means the importance of the text, and the ideological linguistic framings.

§Conceptual poetry: inventive networking (mundane poetry): The death of the text means the importance of the social network, and systematic formulaic rationality.

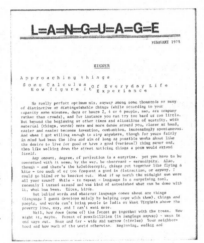

Michael Corris of Art and Language: "The collective is a stable group of individuals who are trying to develop an index of their commonality and who are trying to build on that understanding in order to construct a common culture. To work as a collective is to question how this commonality is reshaped, reformed, negated, or intensified by the conversation. This conversation does not necessarily have to proceed in a dialectical fashion toward a particular end; it is more related to Bakhtin's notion of a dialogic conversation, which is without a pragmatic aim—in other words, conversing just to see what might emerge in and through an untrammeled exchange. A stable group is a necessity for being able to maintain that sort of fragile social encounter."[22]

Language poetry certainly falls back, as all schools of art do, on certain forms of cliquishness, but also there was an openness and mutability of forms in contrast to closed forms or merely visual description.

Lyn Hejinian: "Difficulty and its corollary effects may produce work that is not about the world but is in it. The difficulty of the work, then, does not constitute an intransigence; on the contrary, it is the material manifestation of the work's mutability, its openness, not just a form, but, more importantly, a forming" ("Barbarism," *The Language of Inquiry*).

Barbara Guest: "art that is created is infinitely susceptible to new shapes because no shape can be regarded as final" (*The Forces of the Imagination*).

Ann Lauterbach: "Poetry resists false linkages...Both conventional narrative strategies and the mimesis of visual description are inadequate to the demands of contemporary experience.... Resisting false linkages while discovering, recovering, uncovering new ones, poets might help sweep the linguistic path of its polluting and coercive narratives, helping us to re-perceive our world and each other with efficacy, compassion, humor, and mutual regard."

Certainly, conceptual poetry did not eliminate 'difficulty,' 'chance,' and 'play,' but it is allowed to occur only within predetermined symbolic structures, and they are less so those of language (which is a dauntingly open ended set of limits) but rather the limits of art world-style social economies (what is cool and what is not cool), which can do little more than serve as an allegory for the context determining the content. It does not even test the theory. It just allegorizes it.

In a way, conceptual poetry's most brilliant scheme has been to ditch the impoverished poetry community and fall into the arms of the art world, thereby boosting the symbolic capital of their works.

"The art world excels at colonizing cultural forms thriving at its margins. Why not redefine poetry as a post studio experimental writing

practice? Why don't our great conceptual writers switch affiliations, deign themselves word artists, and await their mid-career retrospectives? I'm being only partly facetious: There are clear advantages to having one's practice subsumed by the art world."[23]

This type of dematerialization (which is really no more than a hyper-materialization, a resignifying, and a price boosting of the poetry book) stands in stark contrast to the previously dominant condition of poetry making: the imaginative play that takes place outside the symbolic order, the play with signifiers of a certain stream of Language poetry (though certainly not all, as the *Against Expression* anthology proves the precedents for conceptual poetry can be found pretty much anywhere one wants to find them).

Famously, the contemporary dematerialized art object leaves a buyable trace—and some art is more buyable than others. (Only some 'queer' outsider art works are discussed in the academy.) This is a basic and obvious fact and yet it is so rarely mentioned, lest the critic be caught with his or her pants off. And then they would have to actually defend (to nobody other than themselves) the real reasons that they set up the criteria that they use. Critics have not been trained to justify their work to themselves, have not been trained to boost their own will, anymore than most art students know how to produce art without thinking first about teachers (later they will think first about dealers, collectors, and critics).

Flaunting this predicament is conceptual poetry, which by dematerializing poetic writing has fallen back on the dominant structures (even 'languages') of the visual art world and its hierarchies (ruled by Duchamp, Warhol, and Sherman), which, in and of itself, is known for dematerializing the art object (and therefore falling back on the power plays of networks and communities). This reemphasis on networks is a key way to receive power: Joselit in *After Art* (Princeton University Press, 2013) celebrates art that is 'connected' and spectacular. Here I thought I'd just give some quotes from Joselit, none of them are made up, and I hope they will offer some substantiation of my points about queer structuralism. His writing provides a rallying point for these

issues because he finds queer theory and Occupy Wall Street and the dematerialization of the art object and the networking superstar and the meme all to be the most radical, exciting things ever (and anything that reminds him of this stuff should be bought and collected by major collectors immediately)! "The point is not to deny this power through postures of political negation or to brush it under the carpet in fear of 'selling out.' The point is to use this power" (86-91). Institutional critique since the late '60s "parodies the power of art without either adequately defining it or coming close to actually distinguishing it" (91). For institutional critique: "either art's power is ethically corrupt or its power is nonexistent. As a corollary to this there is a lingering tendency to regard art's power as virtual—as an epiphenomenal reflection of other kinds of 'real' power, such as capital. I have tried to demonstrate that, on the contrary, the organization of the art world—its format—is as real as it gets when it comes to capital's effects. It's not just the purchase of artworks, but the self-image of entire nations, the transformation of neighborhoods and cities, and the fashioning of diplomatic identities that art is capable of accomplishing. In fact, its power has probably never been greater" (92-93). Ai Weiwei uses the power of his fame to express "dissident opinions." "Ai's political work did not result exclusively in object but in the exercise of power" (93). "In Fairytale, Ai did not critique the power of images—he exploited the power of art to transport people and things both spatially and imaginatively. This is our political horizon after art." "Not every artist has the opportunity and capacity to speculate on art's power exactly as Ai has done, but all can—and I think should—do so in the same way." And, lastly on the Whitney Biennial: "[what it does is to] 'occupy' the Whitney—and hence the attention of its considerable audience—with reformatted forms of media that are usually associated with online sociality enjoyed in private. In other words, 'immaterial networks' enter the museum with 'material' traces, and this turns out to be very poignant. The museum can slow down the pace of online life and exhibit its frayed edges. I can't help adding that I found the Biennial one of the queerest shows I've ever seen (my private term for it is 'melancholy camp'—a kind of camp form without the exuberant flamboyance that the compression of the closet created). This is free-range camp—and it doesn't seem a coincidence that it arises just as

gay marriage becomes the most visible civil-rights demand for lesbians and gay men. Camp, after all, like the Internet, is a private language directed toward building networks!"²⁴

Language poetry (I would say this too of Bataille and Marcuse) seemed on the surface to be optimistically utopian (particularly vis-à-vis Mc-Caffery) but was secretly infused with a bitter pessimism towards all relational systems and communitarian identities. Conceptual poetry (and 'death-driven queer theory') seems on the surface to be pessimistically dystopian but is secretly infused with warm optimism towards all relational system and communitarian identities.

Likewise the little not-too-hidden secret of the anti-postmodernist, Žižek, is that there is a payoff, and a closure, and that he can get away with this, can justify his aesthetic, political, and psychological homeostasis, by means of calling this very 'stasis,' this very reliance on traditional master signifiers the only possible radical act, even an act of 'love.' Likewise Goldsmith's repetition of Warholian homeostasis is defended by Marcus Boon as an act of sacred enlightenment on par with the teachings of Buddhism. And Place's work can be seen as a kind of cruel queer lesbian love (has this dissertation been written yet?). Is there not in Place an underlying "sweetness"? Her works are, at least, touchingly 'considerate' and she fights in her day-job for an impossible messianic freedom from the law that she nonetheless obeys dutifully! It's heroic.

There is, then, within this post-postmodern (conceptual poetry, post-conceptual poetry) reduplication of negativity, a masked positivity that by so brazenly construing itself as so negative, too real, so mean, and too ruthless, detracts attention from the art being made that is negative, mean, ruthless, rough, and hardcore but is not as gleefully insistent on being signified, as such.

I wish I could end like Varadi has ended his piece: "In the meantime, it is undeniably necessary for some of the smarter, more dissatisfied parties on the fringes to step up and step out, and truly shake things

up." I wish I could end like RuPaul would: "You better work!" But I really don't think you need to do any more work for them, sweetie.

51) Queer structuralists/queer conceptualists, born after 1960, have turned fully against poststructuralism and the determinism of the language prison house in favor of a return to structuralism: i.e., structures as something that can be objectively determined with the human rational subject having some sort of ability to do this determining between what is queer and normative, for instance. This has in common Badiou's belligerent ontological turn against Kant's epistemologies and the later linguistic turn of Wittgenstein, in favor of establishing universal and meaningful (rather than chaotic and splintered postmodern) post-postmodern criteria. Here, the structuralists of *October* art criticism (who wrote at the time of poststructuralism but eschewed anything that resembled its tenets, like Language poetry) also come into play, for also rejecting the notion of splintered linguistic relativism, in favor of abstract reasoning and charts, i.e., structural knowledge that, as long as it is being carried out by the most advanced specialists in the field, will always be the most correct and the most avant-garde. Queer structuralists follow the mathematically-oriented structuralist impetus in Barthes and Lacan rather than the poststructuralist linguistically oriented impetus (the impetus to lock us in to our egos and our authorship is eschewed in favor of a notion of subversive efficient political agents who are always in the right, because they can humbly look past their own egos through empathy and curiosity towards the great outdoors; the messy inventive sophistry of Barthes and Lacan is also eschewed in favor of a recapitulation of their precisely formalized sides).[25]

52) In contemporary art criticism it seems that the artwork has found a way to traverse the will to power, to undo it or break out of it. Case in point: Critic Jeffrey Nealon praises Goldsmith for delivering the real qua real, dispensing with the need for an imaginative interpretive or even critical response.[26] After all it is in the interpretive responses of the past that patriarchal hierarchies have been formed! Nonetheless, here he has forged his own neutral transparent cool/queer hierarchy (as do most queer structuralists, as do many post-postmodernists, as

do many post-conceptualists, as do some post-conceptual poets). This will be news to nobody who understands that the will to power does not vanish and that attempts to hide it only redouble its effect. Canons are always created in those moments where it seems that this time the canon will be more justifiably produced than ever before. Many of us understand this and are happy to use this knowledge to support our Machiavellian opportunistic hedonism (à la Place). Others of us will work desperately to find a way out of the forgetful impasse that forges the canon. Foucault, for instance, worked tirelessly against the canon's formations of history. And yet, Foucault has been consumed through those formations. Through this queeripedia consumption Foucault has been turned into an icon for the David Halperin-induced gay techno-utopian sincerity-without-hierarchies that Gaga feminists far and wide seem to believe is a reality.

53) A didactic and dogmatic representational system has been made out of the slippery pataphysical negative dialectics, and a poker-faced essential identity has been born. The non-philosopher, post-popstar, after-artist, post-poet has hoped to throw out the need for poiesis. With video game ease, just find the real and the symbolic will follow, naturally. Skepticism of both the real and the symbolic has been given up in favor of an affirmative embrace of both. Despite the fact that we live in an age in which people are skeptical of the symbolic order of white patriarchs, and even disgusted by this, we have failed to account for the ways in which that disgust has become a way of communally identifying, that has forged a new queer symbolic order, an unquestioned and invisible ideology, restricting our singular will in order that it meets the standards of institutional visibility.

54) Within the '70s in avant-garde poetry, some poets, such as Steve McCaffery (b. 1947), drew on the open Bataillean libidinal excessive economy but were nonetheless canonized in a restricted, refined literary economy by critics like Perloff. (Perloff's influential early book, *The Poetics of Indeterminacy*, seems to advocate the value of a libidinal semiotics, though she subsequently moved away from this view in favor of aesthetic hierarchy and calculated ironic efforts that demonstrate great skill.) It has also been argued that many of the

Panel from *Carnival*. Artwork by Steve McCaffery, 1967-70. Courtesy of artist.

'70s avant-garde poets themselves fostered such a restricted economy, through their own academic affiliations and cliquishness (particularly criticized on this count is my father Charles Bernstein, who taught at SUNY Buffalo with Robert Creeley and Susan Howe, and then went to University of Pennsylvania, where he joined Bob Perelman, and later'd be joined by Goldsmith). More accurately, it can be said that these poets participated in a rigorous and negative dialectical (swerving between closed and open economies) mode of close reading that can be found in other '70s radical movements such as deconstruction and historicism.

Amy King (who studied at Buffalo), Eileen Myles (b. 1949), Christopher Nealon, and others have made an effort to point towards the repression of affect in the dominant strand of postmodern avant-garde poetry in the '70s. In contrast, as Matvei Yankelevich has suggested, there are a slew of poets working in and across a range of practices not just within dogmatic formation of affect versus irony. It is from this disdain for the Perloffian canon that a new canon will emerge and the post-conceptual poets will find their home. But this can only happen if we forget our own will to power and condemn the will to power of the people that came before us. And the best way to do this is to attack Perloff, Bernstein, and Goldsmith.

55) One way to protest hierarchies is by claiming to have found a cool, punk, or authentic way to get outside of them. People are rightfully upset about certain hierarchies that signify exclusive oppression, but rather than acknowledging their own will to power in protesting these hierarchies, they hide behind a cool queer neutrality. Eileen Myles's response to Perloff falls prey to this mode of response. She calls out

the Perloffian canon for ignoring and even silencing the affective, quotidian stuff that falls outside the rubric of acceptable irony, but makes a Perloffian exception for some lyrical affective stuff only when Language poets slide it discreetly into their work. This is a fairly sharp and astute reading of Perloff. And for many, it was also liberating.[27]

56) Updating the paradoxical exchanges between open versus closed economies and irony versus affect, Goldsmith's work has found itself as a contemporary juncture for these competing value systems to wage war. Perloff sees Goldsmith as an exemplar of avant differentiation from the muck of democratic culture. Nealon sees Goldsmith as disappearing those hierarchical marks of differentiation and giving us a slice of ordinary life. Then there are those who see it as the work of a banal talentless hack: not making or disappearing hierarchies but simply staying put in the *mise en abyme* of mediocrity and privilege (those who take the "uncreative" badge very very literally). One of the reasons Goldsmith's work has been able to find unprecedented popularity (leaving aside its large numbers of detractors) is that it appeals to two incredibly different value systems: the system that values the dissolution of poetic canons and the system that values poetic canons. In this way, he is anti-poetic and poetic, conceptual (against expression) and post-conceptual (sumptuously expressing the melancholic paradoxes of being 'against expression'), symbolic and real, normative and queer.

57) On the other hand, Goldsmith's less canonized second banana (here with a pseudonym) Bob Davidson, might, in all, be more interesting than Goldsmith because he is less accessible. That is, his work is not so easily able to appeal to the system that values poetic canons (à la Perloff) but can seem to dissolve hierarchies. Nonetheless, a more common response to conceptual poetry in general will be one that finds it stuck in mediocrity and privilege. To mimic this reactionary discourse for a moment: *"Bob Davidson stinks: His work belongs in the garbage and not a library ... or even more pathetically, in a gallery room of art made in the era of the master, Kenneth Goldsmith. It holds up as poorly as most of the flarf spam folder poetics. Yet, of course, certain stars and geniuses, those who employ these methods 'first' or 'best' or 'in the limelight' rise to the*

top. *If Kenny's work does not properly fold in to the canon provided by the library, he made it so that it could fold in very smoothly with the art world. Davidson's work fails to do this and therefore is more true to the promise of conceptual writing than Kenny's, i.e., it is more truly banal. It folds into nothing more than the garbage. It is like any old periodical. It appears, then the one motivation that remains in the enterprise of Davidson's aesthetic impotence is then, if not to be crafty, if not to be intelligent, then only to be not not-famous, to somehow rise above the garbage, to not be ordinarily mediocre, but extraordinarily mediocre, and how does he become extraordinarily mediocre? Only by playing by the rules: being around the right people, with the right publishers, writing the right manifestoes, and doing the right thing. That is, he has not attempted to suffer the ordinary mediocrity that comes from those writers who write for themselves, or for presses that fail to manifest in the limelight. Moreover, if and when it is pointed out that he has a lack of talent or conviction, he can milk the 21st-century fact that hating only adds comments to the video, and therefore no critical indent can be made, because critique is an internalized part of promotion, if not part of the very content of the work. He can do what the 'institutional critique' faction of the art world has done for years, which is very abstractly internalize the critique posed against their own work (for instance that it takes the place of craft and intelligence and wit) by simply adding it in to the work's self-conscious awareness of impotence, but never face that critique head-on at a ground level. Thus, for all the rhetoric that poetry is dead, it would be more accurate to say the critic is dead. They have been internalized and lobotomized not just by the appropriative ironic internalization of the artist but also by the critics themselves, who have lobotomized their own uncanny human electric ability to pierce deep in favor of giving abstract, communally sanctioned, and always prefabricated crits."* (This is not my opinion, btw. I am a big fan of Bob's work, and am also applying to graduate school at a place where he teaches, and would love to grab coffee.)

Does this reactionary position prove, then, that Davidson is secretly the ur-conceptual genius, and has truly pulled off an act of radical impotence? Or is he, rather, just an ordinary bad poet, as there are ordinary bad poets in every school of poetry? Is he a genius for being such a bad 'bad poet' or is he just a flat-out bad poet? The problem here is that if his inability to achieve enduring relevance is supposed

to mean *something* (i.e., calling into question the whole genius theory apparatus), then in order to say this one would have to make a claim for the specificity and genius-ness of Davidson's uninteresting banality. Thus, it would be a poetics that is far too redemptive and therefore as 'complicit' with the genius theory of dandyism as Goldsmith's work. Therefore he is in a bind: To make his work radically impotent it must fully drop into the periphery and matter only as sociological waste, on an equivalent level with periodical garbage and spam mail. However, he does not ever plunge so far, and, instead, maintains a pretense of 'pining for the canon' and attempting to be meaningful and successful. This pathos, that the work 'still tries' kind of/sort of to be good and relevant is perhaps, in the end, a melodramatic failure to fail that makes the work finally doubly impotent (and this doubled impotence is perhaps the work's last refuge to being talked about over time, therefore losing its impotence).

Those who watch Davidson, as many a post-conceptual poet might, can sort of look to him as a way to redeem the 'bad poet,' and the banal follower, by creating a sublime effect that allows a reader to witness the labyrinthine maze of paradoxes around judgments of merit in art that are usually neutralized. However, in a world where it becomes increasingly commonplace to play around with such paradoxes (especially old to the Internet, where now we are all failures and amateurs, trying to capitalize that amateurishness into fame), the labyrinth becomes a little bit more obvious, and the shtick becomes that much more irrelevant and boring ... but then, also, potentially that much more interesting. But, it is still too commonplace to matter to the traditional archives, and therefore, the only mode that will end up being used to select good from bad in these competing commonplace enterprises will be that of opportunistic fancy. Perhaps this is always the case with the selection of an art star. And maybe that is too obvious a point (one that can be made quite clearly) to spend one's whole life attempting to convey through artistic practice. Especially since when you open your eyes, even just a bit, you can see that there are tons of more interesting points to make and it will be hard to make more interesting points than that in post-conceptual poetry. However, these same points start to become quite engaging when they

escape the terrain of white male melancholy and begin to relate to the problematics of feminism, as happens in the work of Place, Low, and Le Fraga—since in feminism, to be quite crude, the stakes are higher, as the referent in question is not merely a case of blue balls.

58) If Language poetry is full of ironic emotions, then conceptual/ post-conceptual poetry is full of emotional irony. In Language poetry one would find "I'm sad" firmly within ideological quotations. In conceptual/post-conceptual poetry one finds sadness in the exhaustion of compulsively produced ideological quotations.

59) The cachet of those modes of thought that have followed up on postmodernism—such as conceptual poetry and post-conceptualism and post-postmodernism and queer structuralism—is not merely in their claims: to be post-human, post-phenomenological, non-philosophical, robotic, or to have some improved access to non-human super-real truths or to have erased dogmatic subjective relativistic categorizations. These modes of thought continue to thread forward the lineage of poetry and philosophy, and remain centered around the subject of the author, and still link themselves to the same institutions. Therefore, nobody has actually changed their minds. Nobody thinks we are all artists. This is similar to pointing out that, of course, Language poets were obsessed with their authorial imprint (i.e., we do not need Kent Johnson to keep using his name as he lets us know this). For instance, see Jackson Mac Low: "it may be most correct to call such verbal works 'perceiver-centered' rather than 'language-centered' (and certainly rather than 'non-referential'). Whatever the degree of guidance given by the authors, all or the larger part of the work of giving or finding meaning falls upon the perceivers. The works are indeed 'perceiver-centered.'"

60) I saw the best minds of my generation destroyed by Facebook, writing academic theses on the 'starving,' 'hysterical,' 'naked,' dragging themselves through the Zurich museums at dawn looking for an angry fix.

61) No matter what else has changed, there are still celebrities.

62) And the celebrities that manage to succeed best in the queer structuralist, post-conceptual poet, post-postmodern climate are the ones who can enjoy the machinery and use it well: the happy pothead video gamer (Cory Arcangel, Ryan Trecartin, or Mark Zuckerberg and Steve Jobs): those who show with hope that one can still sell

Super Mario Clouds (Cory Arcangel, 2002)

videos/film/movies after YouTube, or books after torrents) and so on and so forth Obama Optimism (uncreative writing ... becomes ... creative writing; blackness becomes whiteness; queerness becomes normality).

63) We are only reading the most-read links, only are viewing the most-liked videos, masturbating to the image most masturbated to, befriending the most befriended friend. We are engaged in a large-scale popularity contest whose vocabulary is so universalized that even the most marginalized, un-social beings are thrust into the middle of it: since it is so decentralized, we are all its center. We are unavoidably unavoidable; there is no surreptitious way to sneak in. At once, we are a meaningless drone (whose sole purpose is to click on advertisements) and the very center/reason for the existence of the Internet.

64) Everyone might be a celebrity, with their own personal news feed, their own personal search results catering to their tastes, interests, and friends (keeping haters and opposing viewpoints out, unless they have been checked and balanced by how many likes they have received or have been moderated by a neutral Wikipedia editor). Queer lives without straight, never put into the sort of violent confrontation that would disturb the process of identity formation. Gay men will remain post-traumatic subjects, cheered up by the market; straight men to remain unblemished bullies. We rely on each other by 'not relying on each other' and that is the gayest thing of all.

65) None of us are celebrities anymore. Meanwhile, some people's personal news feeds explode with a high saturation of impartial observers. They rocket into queer structuralist fame. They become the celebrities who exist after the age of celebrity.

66) We are all celebrities with our own Facebook Timelines that grant us instant retrospective iconic status. Plus its monstrous desire to absorb us all, gobble us all up, like a crazy photo album run amok, extends itself over the whole globe. Facebook is not just for the Western middle class; it is for everyone, from the Western proletariat to the third-world revolutionary.

67) I wanted to become a video artist and was excited by how easy it was to trespass into that space by using cheap video equipment and posting my videos on YouTube. My father would share my video links with his Facebook friends and I felt, already, like a superstar. Then as I became interested in being a curmudgeonly dissident, I found that was easy enough to do by blogging, downloading theory from a popular underground torrent website, and using UbuWeb. What I always wanted to do was have that kind of implosion/explosion that made Stefani Germanotta into Lady Gaga. I wanted to find my Ur-Self, the one who could be as equally monstrous as the machine: could eat it up for my own purposes then spit it back up at haters. I thought putting it all out there might do it, and in a way it might obliterate me. I've yet to have this exciting transcendental moment of excess turned perfection, surplus turned into meaning, like a Trecartin acid trip after which life all makes sense.

68) Taking acid and reading queer theory is as normalizing as having a lobotomy and buying a refrigerator.

69) My sister, the photographer Emma Bee Bernstein, of the same age as the post-conceptual poets (1985-2008), imbued irony learned from our paternal heritage with as much disturbing nude confessional affect as possible. In committing suicide, she seemed to find a way to give herself over to the image of fame, to the extent that the image possessed her: She became embalmed by everything she had made,

which all took on retrospective radiance, all of which could be bought and sold as an artwork. She crystallized her suffering and rage into one giant performative climax and said, in a post-feminist murmur, that she was reclaiming with agency the role of the suicidal femme. Yet she did not have final control of the apparatus that would control and document her suicide: its transformation into Google-searchable gossip, her life cemented in a series of status updates on Facebook. The last being "Emma is Charles." (Our father had just visited her in Venice before she died.) I was given her iPod when she died and played it all the time ... just another technological artifact that seemed to be stamped with her aura, and on it a final On-The-Go playlist. The song: Elizabeth Harper's "Charles Bridge," replete with enough overdetermined and haunting 'messages' to function as a kind of post-suicide note.

Self-portrait from "Masquerade Series." Photo by Emma Bee Bernstein, 2006.

Self-portrait Licking Knee. Photo by Emma Bee Bernstein, 2007.

Stopped on Charles Bridge
He cleans her face
Kissing tears of joy
Trying to erase
Feel her photos laugh
To hide from sorrow
Safe inside a castle
I can hear:

Untitled, Venice. Photo by Emma Bee Bernstein, 2008.

Tomorrow, tomorrow I'll wait for you
Tomorrow, tomorrow I'll wait for you
Tomorrow, I'll wait for you

Have you ever known the joy in the ending?
Have you ever felt the sunset through the sky?

I broke. When I knew. I was leaving.
If I make it over, will you still love me?
Will you still love me?

Tomorrow, I'll wait for you.
Tomorrow, I'll wait for you.
Tomorrow, I'll wait for you.

Stopped on Charles Bridge for you.
Stopped on Charles.

Did she find a way to differentiate herself from paternal lineage, the *mise en abyme* of irony, or did she find something that *looked* subversive but nonetheless gave her away totally to the conceptual apparatus marked by the name-of-the-father?

Back to Black. Photo by Felix Bernstein, 2010.

Oedipal battles are more discernible than sibling rivalries but not necessarily more important. I have anger towards everyone who stands where Emma fell: those who demonstrate conceptual mastery even when they demonstrate 'queer' or 'feminine' failure. But in the end, I also stand where she fell. I am glamorous, while she is rotting. Yet this may all be no more than a ruse to conceal my anger towards her: leaving me with debris from a very troubling emblem of the post-conceptual poet and the queer structuralist.

Emma was troubled with Amy Winehouse receiving so much media attention for being out of control 'cause she wanted girls to live like rockers without all the 'concern.' Like Emma, Winehouse faded fully to black: It was not merely a performative ironic gesture. And, though her conceptual ironic parodic pastiched

Trisha Low

image remains, and that image to some degree produces a signifier that can incorporate the madness that was her decline (her lack of choreographed and intentional work can now become replayed as a kind of choreography of 'madness'-as-concept), nonetheless, with her death, her 'work' truly did cease. No matter how you may tease her corpse hair into a Ronnie Spector 'do, her posthumous fame bears just a shadowy trace of the raw madness of one who really left the apparatus behind and faded into a blacker black than the black that will mark her legacy.

70) Kenny is a wonderful dandy. But now we are all dandies. Dandyism, as Baudelaire meant it, suggested a type of difference, through style, that distinguished one from the crowd, and the middle-brow leveling mechanism of democracy. This power was gained not through conventional work nor money but a parodic, self-conscious, aesthetic labor (as RuPaul says, in a refrain that supports camp labor, "You better work!"). The dandy's style suggested a refusal to compromise, a rebellion against the typical social order, a certain protest against

Felix as Leopold. Photo © Lawrence Schwartzwald, 2014.
No reuse without permission.

normative work but nonetheless there was always a degree of complicity with the class system. Yet the boundaries between the dandy and the crowd were intact. What happens when the crowd so greatly replicates the dandy that there can be no distinction whatsoever? How does one pair the socialist humanism of Oscar Wilde with his aristocratic dandyism or how about the fact that he was at times a mere pedophile looking for lower-class Arabs to impress and fuck? As with Nietzsche, is the disordering of value systems merely a way to hedonistically affirm one's personal proclivities or does it carry a darker undertone: that there are no values and only a disturbed perverse will to power? Why does Foucault, versed in will to power, nonetheless choose to end his life espousing a narrow set of values that emphasize the hedonistic luxury of the Greek man-boy dom-sub situation? When I say Kenny not Kenneth does it annoy you? It annoys me when I hear people say Judy instead of Judith when referring to Butler.

71) These are the paradoxes of the dandy. One can endlessly reformat and repeat the paradoxes of the dandy (as I did with my recent character Leopold Brant) and it will never fail to titillate. So that is why we all want to be dandies. We all want to be New York School poets. And social media makes our wish come true.

72) As dandies, our life has become a SparkNotes Idiot's Guide to Ourselves. We become full of paradigms: kings of our world and the historians who notate the stories. But, as a consequence, we are now excessively burdened with a dystopic excessive surplus of images of the self that we cannot compete with. Instead, we imitate the machine's precision at changing masks by internalizing its rhythms and become, like Mother Monster Gaga, a robotic fashionista. And this becomes true even of the humblest of web citizens, who use the Internet to mark the passing of alienated time. Even they become a dandy.

73) I can hardly compete with those younger than me, who can produce meta-histories at a far faster rate than I can: coming up with maybe 40 new paradigms a day and even fashioning multiple Facebook pages with multiple selves that are carrying out multiple web lives. And those who will be most successful will be those who can

best manage the multiple tabs and multiple Tumblrs without ever being so dour that they get off the Internet—those who incorporate melancholy and confession into the content of their work without abandoning the same conceptual scaffoldings and without ever getting out of the social network.

74) Hopefully, we will be able to document ourselves so fully that there will no longer be a search for lost time (no more taste of the Proust madeleine; as Place has shown, the 3D printer makes one just as sumptuous). The baby book will become an indispensable part of our permanent record, and everyone will have a post-confessional purge. Jobs will judge us based on how long we took to become potty trained. The gravity of our actions will haunt us from the earliest age. Nostalgia will become a science and we will be able to perfectly retrieve the most exquisite memories at any time we'd like. There will be no errors in our histories. We will be logged and filed from the earliest age by our personal bureaucrat robots, who will manage our various networking activities.

It will be a world where Gaga's Twitter posts are read from beginning to end in cycles like the Torah. And where our preeminent poets can do nothing more than enact half-assed imitations of Gaga's imitations of Gaga's imitations of Gaga's imitations (this has already occurred in LA). A world where everyone is a poet and has a Tumblr and all the content of the avant-garde and pop culture and art is fully disseminated but still only one person/percent (a mother monster) makes all the money and gets all the credit.

75) Most post-conceptual poets have received due praise for making rigorous demonstrations of the problematics of contemporary culture, and although some of the writing may look a lot like '70s Language poetry (as it is a combo of performative ego with the egoless, mechanical), as well as non-minimalist '60s conceptual art, nonetheless by reflecting and internalizing the '80s simulacrum (vis-à-vis conceptual poetry), these writers maintain a distinguishing mark that has very little in common with the utopian signifier-play of the '70s or the Zen/hippie body play of the '60s. They include Sophia Le Fraga, who has

found a way to suggest something of showy confessionalism within
the monotony of webtalk and texting (and who merges concepts that
one might find in Place with vaudevillian antics); Trisha Low, whose
purge is the envy of any LiveJournalist but also of any romantic lyricist;
Josef Kaplan, whose kill list pokes fun at the overdetermined political
judgments that look down upon 'comfortable poets' (drawing links,
as Joyelle McSweeny has noted, between drone warfare, surveillance,
Facebook, and poetry communities); Andrew Durbin, whose dandy-
ish girltalk is so fast that it threatens to explode; Danny Snelson, who
delivers playful, colorful deformations, re-performances, and culture
jammings of the Internet and the avant-archive; Steve McLaughlin,
whose *Puniverse* crosses encyclopediac conceptualism with off-kilter
hilarity; Brian Kim Stefans and his disgusting algorithmic hiccups;
J. Gordon Faylor and Kieran
Daily and their info-overloaded
texts that produce reading sans
perception; and finally Steve Zu-
ltanski, who has autistically com-
bined the typically autobiograph-
ical details of 'imagination' with
the mechanically precise autobi-
ographical details of 'fact.'

X: Haphazardly sampled phenomena
A: Acts
S: Scenes
b: bijection

Subordination of X by treatment of A(S) to result X as Drama

Gpdf089 (Kieran Daily)

Equally exciting, however, are people who seem to elude this set of
problematics and do something *else*—not that something else (be-
sides the problematics discussed here) can't be found in the work of
post-conceptual poets too. For instance, Kaplan's hostility and Low's
punkness hint at a movement out of the irony/affect divide into more
belligerently personal and potentially more romantic/visionary ter-
ritories. Sites like Gauss PDF attempt to drive through these condi-
tions without ever so easily converting the 'general economy' into a
'restricted economy' (or vice-versa) but show the perverse messiness
of those categories.

76) Two poets of the same age and coterie as the post-conceptual poets
who have bypassed conceptual influence altogether are Cecilia Corri-
gan and Lonely Christopher. Christopher draws from New Narrative

and its interweavings of the dark, abject transgressions of Rimbaud, Bataille, Kristeva with contemporary gay life, while Corrigan draws from absurdist comedy—something she has in common with some Flarfists and Language poets. Corrigan, though, has shown much more pizazz than even the funniest of the 'funny avant-garde poets' and in this way borders on a kind of playful accessibility common to those rare crossover art/comedy sensations like Michael Smith in the '70s or Maria Bamford's recent work, but imagine if those two had brilliant

Lonely Christopher

literary skills. The sensibilities of Corrigan and Christopher mark the limit points for what might be possible for post-conceptual poetry but which has heretofore not occurred. And at totally opposite ends: Christopher in the tradition of John Wieners, Corrigan in the tradition of O'Hara. But both busting the seams of those traditions in a way that most of the banal post-New York School poets never could.

If Corrigan and Christopher mark outside points, then, looking within post-conceptual poetry, it is Trisha Low's *Purge* that stands as a benchmark for radical work that can be done within the parameters of post-conceptual poetry. The book, which veers between appropriated girl talk, humorous self-on-self drag, utterly intelligent and astute criticality,

Trisha Low. Photo by Nick Salvatore, 2014. Courtesy of artist.

pretty lyric, and raw confession borders on doing that 'new' thing that could crystallize and define post-conceptual poetry as legitimately dif-

ferent than what came before: for Low has internalized and worked through the death of the author and the death of the text (and is therefore able to seamlessly manage ideologically satirical cut-ups à la Language poetry, as well as blatant amoral appropriation à la conceptual poetry) but has also begun to push beyond this and press towards the death of work. This is not an abandonment of rigor or structure (as the work is obsessively structured and shows biting rigor) but rather an abandonment of the ties that bind the artist to assert a kind of 'mastery of work' to appease critics and audiences in lieu of reaching that 'vanishing point' of brutalized madness that is not marked as 'madness.' This is why madness might not manifest here as 'not working' (anarchistic hedonism) or 'excessive working' (as it did for Foucault, not to mention Goldsmith) but rather working under the confines that one sets for oneself, as opposed to the ones set by others. Of course, doing this might have appeal to others (from the passing engagement of a scowl to the enduring normative interest that keeps Artaud in the canons). Indeed, Low's work is among the most appealing and talked-about of the post-conceptual poets. But in a sense, all that chatter conceals a longing for the sort of 'abandon' showed by her work that most in the 'crowd' cannot achieve. And it is here that an avant-garde might always crop up, just as an asylum might always crop up, because only so very few are willing to abandon the demands of their time, and those few must be housed and categorized accordingly. Thus it is that post-conceptual poetry, a truly vapid and historically uninteresting category, houses several gems that will nonetheless always, to a great extent, be bulldozed over by the boundaries enforced by the stupidity of the phrase 'post-conceptual poetry.' Likewise, the 'death of work' (and its symmetrical counterpart 'the death of the reader'), which here I speak of with a romantic appreciation, is just as likely to produce a book like *Purge* as it is to produce dull, mindless writing that reflects an age of outsourced labor and very schticky disappearing acts ("Look, I disappeared into a tired-out but updated-through-reference-to-the-Internet drag persona and 'subverted' what the Midwestern straight male spectator expects, or expected in the 1950s.") instead of the sort of dangerous disappearances that actually risk losing visibility to the spectator.

So much art done by those born after 1985 shows a lack of rigorous commitment to visionary and critically dialectical struggle and threatens to be totally lost in the complacency of Facebook event marketing strategies rather than 'praxis.' But that is not bad or worth condemning. Because that would mean throwing out what is potentially singular and disruptive about this period, which will not just be established by those who manage to rise above the mediocre middlebrow but will also be established by those artists who have risked plummeting into the abyss of the mediocre currents of the contemporary but somehow rose above it.

And, perhaps most disruptive of all (and most dreaded by those who fight for the prize of canonized poet) will be those who took the risk of being mediocre and complicit and drowned (failing to leave a distinguishing mark). And even more important—something Low's art already does—is the potential of art in this moment to throw into question the very sort of 'difference' that is proposed by oppositions such as the one I just used (swimming versus drowning, marked and unmarked). Questioning of this sort of opposition is found not just in works by bona fide artists like Low, but also in the non-canonized universe of Tumblrs and blogs that rapidly reassemble these distinctions in such an incisive way that those tried-and-true deconstructed binaries like 'low art and high art,' 'creative writing and uncreative writing,' 'authored and authorless' start to seem antique. Let us hope that the 'drowning of the book' and the drowned woman will not just be folded into opportunism as such, like Place's virtually self-proclaimed sham of an 'editorial position' on the not-particularly-conceptual (except in name) anthology of female conceptual writing *I'll Drown My Book.*

77) Though Language poetry made authors subservient to a larger field of 'matter' and 'language games,' the authors are nonetheless still THERE and not just presented as simulacral decoys, which is what authors become when matter and language are subservient to firing neurons and representational structures (a kind of restructuralism) à la conceptual poetry. What has been abandoned in post-postmodernism is what was palpable in post-Language poetics (especially

the work of Elizabeth Willis): a search for the somewhere else, which would not be merely an escape into the recesses of the heart or the structures of ideology or the metastructures of neurologically induced frame-narratives, but rather a turn to a somewhere else altogether (that is to say a visionary 'outside of capitalism' that does not fall into academic Marxism or hip queer theory, but is 'non-relational' in more than just name).

Despite remaining uncanonized, there is still recourse to a true despairing that believes in no real (no affect, no queerness) and does not use this *no real* as a means for Baudrillardian solipsism or sophistry but instead fades from all those trace structures that claim fidelity to 'radical events.' Something close to what Low describes as the 'actual mess': "i think that performing a feminine mess involves all the markers of the grotesque, but that always seems somehow limited to the page or to a symbolic space. i was always more interested in making an actual mess not just via overdetermined referents (although i do love those) but in a contextual space, socially etc.—in quite a literal way, the ways i want to make a mess are ways that are already so firmly disallowed or silenced that they are already illegible, and therefore can never be carried out to their completion, not visibly anyway."[28] A real fading to black. And the fact that this will never be properly canonized, and cannot be properly canonized, without a drastic erasure (so that it will be marked as 'madness' and thereby turned into a kind of normative definition that eludes what it is describing) is what is so disruptive and exciting about certain works of post-conceptual poetry.

78) Like Robert Grenier's search for the unspoken word in the 'back of the head,' or Hannah Weiner's silent listening, the quest to find the deeply idiosyncratic, non-habitual word does not necessarily signal a rupture in the symbolic order that totally bulldozes over the system in place and then puts in its place a new authority (or else fails). Rather these more miniature 'revolutions' bring forth the unseen into the seen without necessarily enforcing that they be seen through coercive power tactics. This is a paradisiacal respite from the ordinary trappings of power, and all the many orders it operates within: the real, imaginary, and symbolic. Such work seems to operate mostly

at the level of the imaginary: a
subtle engagement with the ego's
conscious perspective on the
material world, with letters and
words, as well as, quite explicitly,
the imagination; and with defer-
ence to the order of the symbol-
ic and the order of the real, but
with a refusal to give in to either
one. This is to provide everything
a chain of never-ending contin-
gencies, and functions like the
ever-contextualizing neutrality of
the historicist that Žižek derides
for failing to reduce everything
to a return of the same traumatic
kernel of the real, manifested re-
peatedly through the appearance

Hannah Weiner. Photo by Tom
Ahern, 1978. © Tom Ahern.

of incompatible differences. The acceptance of this 'limited' agency
of the artist contrasts with the Maoist revolutionary or the Warholian
ironist (both symptoms of the restoration marked by the '80s) though
it certainly can overlap. The latter two are committed to the symbol-
ic order (the first calling for a new hierarchy, the second calling for
complacency). It is possible, however, to call a given Language writer
a Maoist or a Warholian (for their insistence on creating a new canon
but also for their ironic complicity with the academy or pop culture).
Yet, the heart of a work like Grenier's "On Speech" or Watten's "On
Coolidge" is to propose an alternative to any such commitments to
hegemonic symbolic orders (the hegemonic order of speech and its
hegemonically enforced juxtapositions).

79) The poststructuralist attempt to subordinate meaning to language
has been followed up by the post-postmodern/post-poststructuralist
attempt to subordinate meaning to neurological transmissions. Neu-
rophilosopher Paul Churchland's highly influential alternative to
folk psychology's belief in the manifest image of humans is to give us a
scientific image of humans: as a bundle of firing neurons in a network

of cells. The postmodernist/poststructuralist valorizes human intuition and ontological play and resemblance (being in the world, being in language), while the latter finds humans to be rather insignificant compared to meta-human structures, as well as 'reals' (in the outside world) that escape cognition. This has split repercussions: On the one hand, it can reaffirm the dystopian Baudrillardian death of the real (conceptual poetry); on the other hand, it can reaffirm the utopian, queer reals of nature and the cosmos (speculative materialism).

The post-postmodern deterministic reliance on neurological, technological, algorithmic, and cosmological structure does not eschew liberal politics; on the contrary, it makes Marxist-Hegelianism seem more possible and also makes dogmatic procedures such as those prescribed by queer theory seem more probable. That is because dogmatic formalism becomes altogether more cleanly performable when the subject is so deeply relativized by queer structural mathematic precision.

The split manifests in another way as well. One group believes that having discovered a world of the real outside of the human mind, we can finally ditch institutional legacies of science and the subject (non-philosophy, queer theory, late affective Romantic lyric), the other sides claiming that such radical departures from traditional subjectivity must be found precisely through science, psychoanalysis, mathematics, politics, and the avant-garde (Badiou, Žižek, and conceptual poetry). Nonetheless, both sides of the split continue to rely on systemic formulations and institutional housing, but only the latter will admit to this.

80) Post-postmodernism is potentially nothing more than a mimetic refashioning of our contemporary global situation: We are kept at an alienated distance from the art of war, from the medium of war, from the imaginary of war, from any visionary dismantling potentialities of war. Meanwhile, the government stores up massive information in warehouses (not to mention its storing of prisoners) without any useful interpretive apparatus, which could potentially disturb the entire apparatus (from the NSA to the prison-industrial complex). Instead,

the punctum (the guilt of the traitor) and the studium (the compen-
dium of information) are glued together, as if in perfect harmony.
This could be argued to have a grim overlap with conceptual poetry
(and there is even a self-conscious overlap in works like those of Josef
Kaplan). The real is in that punctum; we don't need interpretation,
just search-and-destroy engines to grab the real and expose it to the
world. And maybe this is the world we live in. Whereas imaginary
tactics would have us decompose (Percy Shelley, Étienne Bonnot de
Condillac, Sigmund Freud, Jacques Derrida) the world to find truths
(unstable or not, depending on your bent), the world is no longer in
need of decomposing. We have it as a given formula, and must rather
hunt down the real, as if we were in a video game, finding it glowing
brightly in and of itself. The work of the philosopher and analyst and
poet and artist is no longer needed; the real is just there already. The
studium will deliver us the punctum; we have faith. Any of us can
be queer professors and find out this 'truth' for ourselves. Using our
Mac computers, we will all be connected through the shared fact of
having peculiar tastes/disgusts, peculiar base relations to the system
that can then help us to link to the system.

81) It would be easy if the whole world were just an amoral thing.
However, negative dialectical poststructuralism is not dead; there are
still formulations of it, from Cartoon Network's *Uncle Grandpa* to
Corrigan's *Titanic* to Ray Brassier's *Nihil Unbound*.

82) Am I, is this, neoliberal *mise en abyme*? Am I, is this, inscruta-
ble drivel? Have I, does this, seek critical redemption? Have I, does
this, offer critical redemption? Have I, does this, align totally with
the museum, with my father's name, with Kenny Goldsmith's name?
Have I found, is this, the proper exhibition space to make my points
seem properly removed from the *mise en abyme*? Doing this now, and
questioning my ties to the name-of-the-father, aren't I repeating what
my father does when he questions his ties to the name-of-the-father
(his father Herman who signified normative '50s American culture)?
By struggling with Kenny's struggling with my father am I rebelling
against anybody or arguing with a brother or myself? Should I, does
this, suck up to Language poetry? Should I, does this, suck up to

Drive-By. Painting by Susan Bee, 2009.
Collection of Rachel Levitsky.

post-conceptual poetry? Does this, can this suck up to my mother and feminism and M/E/A/N/I/N/G magazine? Should I, does this, don't we all, forget about the promises of feminism? Do I, can I, love Vanessa Place and my father and my mother and Kenneth Goldsmith and Trisha Low and my sister? Can I, do I, love by, and through, critique alone?

83) Place: "One might think of poetry as being ideologically exempt, but it isn't, for we are fully embedded in the symbolic order, and everything we do is evil, and rather than ever risk hypocrisy for what we do, we must admit it immediately, make it apparent, and parody it, we must constantly identify as the perpetrator to show and expose that we are one, and allow ourselves to be 'killed' when the revolution comes, never protest your guilt. The toughness of the law exerts itself always, even in places where it is evidently not acting: like poetry or other 'inclusive' institutions. Power still operates in poetry and creates inequalities. Therefore, there is no 'good' haven that is separate from the 'evil criminals' who we scapegoat for all our problems."[29]

The negative dialectics of postmodernism/poststructuralism (including Language poetry) meant a play of negations and inconsistencies that goes between the rule and its exception, a play with this does not necessarily form a meta-authorial mastery (though it often does). Whereas, Žižek's transcendental materialism, subsumes all difference and distinction to a structural logic that is inside the psyche and therefore is idealistic. It is actually quite optimistic and euphorically in line with capitalism's paraconsistent logic.

The speculative materialists and non-philosophers and their resurrection of a pure real also attempt to break free from the ironic crystallization of poststructuralist practices into a meta-author. Others flee to a straightforward and mechanical concept (conceptual poetics,

network-based practices). Others still, offer a melding of the two: the symbolic (the concept) and the real (the punctum) and this is what Žižek offers and Place offers and the queer structuralists offer.

Place: "The slave's repetition, the slave's eternal return of the same, highlights the transcendental signifier and ruptures their authority, the slave is signified by another, in another's language, and by repeating the other's language: he begins to master his master: this eternal return of the same, the same becomes difference repeatedly, avant-garde revolutions happen repeatedly, only by slavishly repeating them, can we point to the governing master-narratives, which we are culpable in."[30]

To critique Place: What this disavows, though, is the slave who cannot become a master; who cannot proficiently master the master's discourse; the uncommodifiable slave. And it also disavows the ability to foster new relationships with such 'slaves.' Indeed, Place may be right that the criminal justice system does little to redeem her clients. But locking their words up in a rigidly dogmatic and 'cool' conceptual poetics is no better: it is the 'same' and it does not have to be. Here there can be a difference that does matter, that does materialize. And a poetics that matters, that 'redeems,' *is* possible.

Place mimes the slave who fails in just the right way to please the master. But we do not have to keep repeating the slave's fuck-ups, multiplying abjectness, collapsing it. In fact, there is a certain rage at having to do that, in Place's works, that challenges the more neutral assumptions of Goldsmith's work. And perhaps this sows the seeds for creating art works that stand to elevate themselves, facing all the ridicule that comes with such elevations, and also facing the damage. The student's discourse: the student does not necessarily want to repeat their teacher's work, the teacher must therefore stand as a kind of punching bag, an old relic as it were, to be humiliated, used, and punched in, while the student learns self-satisfaction. For the teacher to be totally permitting is cruel, for some constraints are necessary. Such lackadaisical parenting leads to multiple Trecartin babies running around, knowing not when to begin or end, like little televi-

sions. But rather than letting us face the horror of the vacuum that is our culture, these texts seem merely to collapse the art work into the vacuum, and therefore, give us no time to rhythmically approach it. Besides, the true competitiveness comes out: who can Tumblr or meta-assemble the best? Who can make best use of compositing and pastiche techniques? It becomes a race for the fastest, most productive user of technology: even when it seems to be frosted in the sweetness of irony. We are being exhausted not by the machines, but by our need to be better on the machines than our neighbor. Therefore, while the new aesthetics in the ordinary art world, poetry, and activist context may be reductive, it also provides a nice framework for studying these errors and elevating ourselves above them, as an artist and student ought to, in order to be critical and studious. This is not done to be competitively better than others at being elevated, but to be equally able to stand outside the system under analysis for long enough to pose a judgment about it. And in this way, teachers must sometimes commit themselves to being systematized for long enough that a student may use and make use of them, and then rework the framework in their head. It does not have to be a competition of who can elevate themselves best, or who is the most critical. Criticality cannot transcend the dynamics of power relations in groups: like a classroom, let's say, but it can momentarily be isolated from these dynamics, as a kind of breathing space. If we collapse all the rhythms into that of porn: where everything comes on time, we may be perpetually ejaculating but we might also be missing out on some other joys.

One of the major shifts that occurs in the switch from Language poetry to conceptual poetry (from Madonna to Gaga) is a switch from Derridaean deconstruction, dissemination, chance, and play of signifiers (in lieu of a master signifier) in which all truths are lies to Lacan's rule of the father (his insistence on master signifiers) in which all lies are truths. Lacanians deride the free-flowing "poetics of indeterminacy" that imply a denial of the superego, the denial of the father's power, the belief that he is imaginary, the belief in counter-culture, in protest, in change, are all pessimistically rendered impossible. The Lacanian maxim dictates the work of Place (especially in a piece where she changes each 'woman' to 'man' in the feminist work *The Second*

Sex). For Place, the Lacanian maxim is taken so far towards an almost passive aggressiveness that it might paradoxically foster a belief that woman does exist and must exist. This becomes a challenge to the dematerialization of conceptual poetry, especially when coupled with her work, which serves to bring the material, especially highly affective material, into conceptual poetry. But what once was a critique of conceptual poetry is now just a part of it as Place gave up her place as a post-conceptual poet.

What Place wants to do, like what Žižek wants to do, is to cruelly bring the signifier back into the lives of postmodern subjects, who pretend to be exempt from law and order. The postmodern attempts to transcend distance, to achieve everything, enjoy everything now (mentioned incessantly by Žižek) take us to a 'real' that we cannot ever have and therefore leave us with a Baudrillardian virtual reality that basically sucks. The solution, for Lacanians, is to use the symbolic to understand the real. Žižekian Todd McGowan writes: "Reducing the Real event to a meaning and refusing interpretation altogether, however, are not the only possibilities. There is a third way—that of situating the Real event within a symbolic context. This path allows us to attain comprehension without becoming comprehensive and thereby foreclosing the Real."[31] In other words, the real can only be understood within the symbolic. And even the imaginary, which is so often touted as a radical place in Lacanian theory, is only deemed radical because it will be able to alter the symbolic.

Žižek and Place point repeatedly to the symbolic order's insufficiency (we are living in end times or poetry is dead) but do so only to prop up a 'new symbolic order,' which they can master. If in the past we had

been told 'enjoy,' now, we are told 'feel disgust' and 'you cannot enjoy'—and this is meant to actually allow enjoyment. Just as Place's use of 'woman does not exist' is actually meant to foster the belief that woman does exist. There is, then, even in the darkest, most cynical exercises of contemporary art, the underlying optimism that this will allow us to find a new mode of enjoyment. Just as, more simply, queer theory, by emphasizing a derogatory term ('queer'), is actually meant to allow us to feel affirmed.

84) Not everything is always so separate as periodizing schemas pretend them to be. Queer theory's communitarian identity has something in common with the radically splintered dialects of the masculinist Bruce Andrews. Sianne Ngai demonstrates that blurred line, in her affect studies reading of Andrews, which suggests that by redoubling the excess of ideological artifices, Andrews brings about a kernel of 'disgust,' which we can share, and which can serve, as our 'Real.' This gives us a kind of detachment with which we can 'look' at the falseness of things and laugh, creating a kind of communal bonding. Also it forges precisely the communitarian identity that Andrews both loathes and seeks (the counter-hegemonic one is alright with him). The 'generalized' (queer) subaltern's disgust (affect studies) functions as a mode of identification that leads toward a homogenous monolithic and accurate system, that is 'better than' any particular efforts to render the world forged by the real-in-solitude (a category that is 'absent' in this scenario). Here, these lines become blurred because Ngai loses the radical willful innovation of Andrews and gets weighed down by the need to theorize a collective enjoyment of 'disgust.' The point, perhaps of Andrews, is that he is 'tough' to identify with and creates a kind of blockage in our patterns of identification. Nonethe-

less, there is, I think a kind of linkage between what Andrews does and what Queer Theory attempts to do (vis-à-vis his own reliance on the universal figure of the counter-hegemonic but also his use of vulgar terms), with Andrews perhaps proving more successful because his work has an idiosyncrasy and a hostility that queer structuralist universalist formalism seems to lose.

85) In the academy and art world you aren't supposed to enjoy (as you allegedly are 'demanded' to do in 'neoliberalism'). But you *are* supposed to have a painful understanding of the ideological determination of whatever enjoyment you have. And you are supposed to confess your jouissance (your ideologically determined painful pleasures) to someone else in legible forms. "I am attached to the system in such and such way," and once you admit this you are on the path toward having more power in the system, getting more power from the system: because in confessing you are rewarded, you are respected, you are understood. Basically, through Žižekian psychology, we are forced to admit our jouissance (that is to expose that pleasure/pain that attaches you to the system). In naming your symptomatic ties to capitalistic demands for enjoyment, you can traverse the fantasy of your petty Imaginary ego and enter the Symbolic order anew, constructing a new master signifier and ego ideal to replace the old one (ideally a Communist one but in other parts of the academy, you form a queer signifier). This is tantamount to a new demand (à la Ngai) to confess your disgust and reprehension and negative feelings about enjoying the system. Once this 'negative affect' is confessed you can start to quilt together a new system of possibilities.

Thus a leading queer theorist Heather Love can confess that she couldn't really put two and two together in her emotional life until she could receive the permission to write about her personal life through her dissertation. What gets lost in this emphasis on confession and didactic formalism is that the emotional turbulence that is academically designated as jouissance loses its untranslatability and uninstitutionality: that it might not have to be surrendered over to the symbolic order (to the affect studies journal, to Facebook, to the priest, to the therapist). The work of even the most cutting-edge and

interesting members of the queer academy like Ngai and Lauren Berlant seems to make diffidence and pain into a scratch and sniff coloring book that gives a neat little map of the bourgeois mind.

Felix and Charles Bernstein
(Unchained Melody, 2013)

86) Bonus point for understanding this note and responding to it in your 'review' or watercooler conversation or wtv it is you do.

"The stuff of conceptualism, the textual thing, is the most static of objects, inert Dead as a doorknob. Its representations are radical mimesis because they do not represent, just present" (Place).[32] In line with speculative materialism, Place valorizes the content that dumbly remains after all politicized moralizing interpretation has exhausted itself. Here she offers a very sharp and snide turn against the poststructuralist emphasis on linguistic framings, particularly the idea that one should strategically and self-consciously use seductive linguistic framing mechanisms in politics, a case argued most persuasively by George Lakoff (b. 1941), since these frames animate our lives and identities and choices, and thus are unavoidable. Unsurprisingly, a major critic of complicitly using seductive ideological frame-mechanisms to further one's political causes is Žižek, who is obsessed, always, with the gap in the coherent frame that interrupts its intelligibility.

A different attack on the emphasis of framings was offered by David Micah Greenberg in the *Boston Review*, in his critique of Charles Bernstein's poetry for using tactical and conflicting framings to make skewed political points—in the same way, he argued, that the far right does. Lakoff has long written that the right has dominated these tactics, and his suggestions to the left have been heeded, particularly by Obama, who found ways to present the public with a deeply seductive advertising campaign around the term 'change' that linked up multiple different upsets into one coherent frame through which he delivered his ideological message. And yet Greenberg

imagines Obama's preaching to be free from such ideological framing maneuverings, finding it to be neutral and gentle:

> Obama is a better writer than most because, like Lincoln, he challenges audiences to create space for experiences different from their own. The left's poetry is not always positioned to do so, to present or at least evoke the feeling of the differential texture of social experience, in order to counter those who would obliterate reality and human life when they do not serve them.[33]

Neutral space should be given through which difference can be neutralized, so that even a child could understand it—and thus we take the différance out of difference.

Strangely, though the self-conscious framings of Lakoff inaugurated Obama, it is nonetheless a turn away from self-conscious framings and toward amoral rational structuralist posturings.

Žižek berates Lakoff for putting forward "passionate metaphoric language" and "seductive frames" rather than "rational argumentation and abstract moralizing," but it is rational argumentation and abstract moralizing that is exactly what makes Obama such an appealing candidate.[34] Obama found a way to transform the tactics of postmodernism and its emphasis on frames and deconstructive constructivist readings of speech/writing into a neutral, rational, abstract, spacious sermon. And this is just what the anti-postmodernists like Žižek and Greenberg and Place crave: an end to flippant irony and a return to pure Good (or in Place's case pure Evil).

Obama is therefore a very PC/mainstream version of the sort of Messianic figure that is 'supposed' to come according to Badiousian-Žižekian prophecies.

The PC liberal belief is in a revolutionary spirit that is strong willed and NOT metaphorical but literally authentic despite having a void of non-being at its core. This is a fractured gap of alien immigrant

queer punctums that is identical with the Badiousian-Žižekian revolutionary spirit with one exception: the former's proclivity for liberal democracy rather than for communism.

Aesthetically, if not politically, the PC mainstream democratic liberals (like Greenberg and Obama) share with Badiousian-Žižekian communists a distrust of splintered quotidian dialects (such as those offered by the ghetto micro-cultures and minor literatures of postmodernism) that leave no space for rational abstract moralizing that can create a shared experience and lead therefore to 'change'; that is to say, that Badiousian-Žižekian 'aesthetics' mean never giving up on party politics and a 'majority feeling' (even if that 'majority feeling' is a shared feeling of disdain and distrust). Likewise, Place distrusts quotidian lyrical splintered language that has not been filtered through the party politics and abstract amoral rationalism of her own movement (conceptual poetry).

87) Sharing feelings, through dissertations (à la Heather Love), is not in and of itself the problem; but the mentality of compulsive sharing does foreclose the freedom of 'off the grid' flights. The unmappable confabulations of the '70s were thrown away in favor of the Maoist-Lacanian-Badiousian-Žižekian 'restoration' that peaked in Baudrillard's deadpan '80s (covering over any possibility of punk or romantic escape/secession from the system). See the ways in which homosexual separatism (the radical faeries, for instance) and black separatism and feminist separatism (such as Shulamith Firestone and her notion of literally breaking apart the nuclear family) have been thrown out of the 'picture' of what gay/black civil rights are today. If in Detroit one might romantically note a possibility for secession, watch how it becomes covered over superfast: not by the right wing but by the leftist artists and their desire for an art market.

88) The danger of post-conceptual poetry is to take refuge in the 'progressive' ideal of a widening luxurious middle class, that should have as many 'rights' as possible (legalized pot, legalized marriage), but also have as much outsourced labor as possible. Things should be relaxed, and we should all have iPhones. So much of Gaga feminism and of

Occupy Wall Street were confined to this sort of viewpoint, in which freedom meant freedom granted through corporately owned social media: memes (lingos, Logo TV), Jon Stewart, Stephen Colbert, Napster, and New Sincerity—all are symptoms here. Certainly, Goldsmith and UbuWeb are in danger of giving the avant-garde over to this sort of web utopianism [see Goldsmith on *Colbert*]. The more idealized, luxurious, and leisurely your labor is, the more money you either already make, inherited, or are going to attract. This is not just because we have outsourced 'real work' abroad, but also because we have outsourced our creativity to the past, which we rely on too heavily.

89) By outsourcing labor, habit, control, and rules we have lost our ability to come up with engaging and adventurous alternatives to the structures that dominate us—which is to say, with the Lacanians, that we are "enjoying" ourselves too much. But it is also to say that the way out is not merely to list a thousand ways that "enjoy" has become a dominant demand in the West. Or to find a new master term (post-conceptual poetry, for instance) to settle us down ... but rather, to inventively and adventurously establish rules and habits that we desire (not rules and habits that the party desires).

90) But is this all fundamentally how language works? Is it always a return to the repetitive, the boring, the normative, so that anything truly remarkable will "pop up" as something to be read and decoded as a "punctum" or a "differance" or an "objet petit a" or "bold new artist"? Or else encoded into a *new* significant term that will freeze up within days and need to be displaced again?

91) With the disappearance of a stable 'academy' for the humanities, serious thinking and theorizing and poetics have, more than ever, a pressure to be viral or decorative. (Think of how one does not have to read Goldsmith's work. That's fine for a one-joke thing, but it is inevitably going to be everyone's joke. And this is new. The dandy's proclivity for the decorative was once an illustration of avant-garde

culture's aesthetic turn; however the hyper-dandies à la Goldsmith are more indicative of an anesthetic turn.) The institutions of the visual art, party promotion, and Internet fame have all increased as the academic humanities have dwindled. So, for better or worse, serious thinkers and theorists and historians and critics and artists and poets have to spend more time angling their work for exciting small decorative galleries/journals with viral appeal. That is to say: "appeal to the World Wide Web" rather than "create complex esoteric webs within your own work." Likewise, 'negative queer theory' and its sibling theories, for all their talk of 'non-relationality,' have proven nothing more than compulsory modes of empathetic outreach (to tenure committees and middle-class undergraduates). And thus we must make everything so that it appeals to the World Wide Queer. I mean, have you

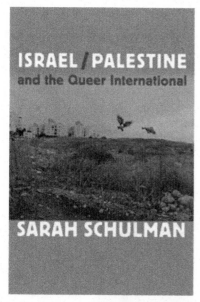

looked into Sarah Schulman's Queer International? Those who endorse this message of queer internationalism get red in the face when they are quizzed about the way in which their work is severely hierarchical, about how it even goes so far as finding queer internationalism as a justification for supporting Hamas. What we see here, as in Žižek's Stalinism and Badiou's Maoism and Schulman's Hamasism, is the use of abject, particular minorities to endorse a global left. From this position, any communal furor and universalized discourse, however vapid and violent and hierarchical, is altogether justified if it takes account of some abstract term like 'queer' or 'proletariat' or 'immigrant' or 'the real' or 'the event.' Instead of using those particular uncounted 'minorities'

Sarah Schulman

as a moment to radically break with the system of communal alliances and to rethink formalistic universalism, they are instead used to justify a constant and never-ending 'recounting' premised on an idea that one can approximate fairness if one makes continual deference to the 'abject' (and here, with all these thinkers, is the paranoia of ever slipping fully into the uncounted—that is to say, losing the status of 'heroic, brilliant, radical' critic, philosopher, or political activist).

92) The next note is perhaps the only truly personal (and autobiographical) note.

93) It has been a struggle, here, to discuss how a given group of thinkers (post-conceptual poets) manages these contradictions. It's hard to discuss things like this, as they occur, in the 'contemporary,' with your friends and colleagues (and family and family friends) implicated, in any serious way because if one does discuss things like this in a serious way (or even in a trivial way), you look very bad. For one thing, you look like you're resentful of the ways people have been able to find 'success' by putting their work out through 'successful' and hierarchical platforms. But you also look hypocritical because you are no better than those people; your critiques are probably disseminated through some sort of hierarchical platform as well.

Art history is written by the curators, critics, and landlords who take the least amount of risk and are in the end the least remembered. And you have to be an utter psychotic (like Jack Smith) to complain bitterly about this to the specific people who 'help you out' as an artist.

Normal Love (Jack Smith, 1963)

Though it's fine to pose it as a glossy and general critique (the kind offered by Bernadette Corporation), it is never fine to bite the hand that feeds in any way that would *seriously* cut you off from the network that is meant to support and indulge your 'negative' perspective.

Nonetheless, I am here taking the risk of looking resentful and hypo-critical (indulgent and juvenile) in order to make the point that——

> As someone who has lived within the gated communities of the 'negative' cultures of theory and art, I am hereby stating that it is nonetheless almost wholly impossible to overwhelm-ingly refuse valorization (of your practice or the practice of your 'friends') at the end of an article in any substantial (spe-cific and incisive) way, due to fear of humiliation and the risk of career injury. And it is this final humiliating limitation that is never discussed: that in the end you must not cut your-self off from *everyone* in the marketplace, only a substantially large group. Even if total hatred of everyone's actions is the most persistent manifestation of the research you are pursu-ing, a craft you have been routinely encouraged to carry to its conclusions, you are nonetheless supposed to make an exception for the pocket fringe microcollective or journal or curator or publisher or parent or friend or gallery that will support you. You will inevitably be forced to gag on the cock of community and family (even if this community and family is some sort of neo-*Paris Is Burning* anti-family parodic-family post-family or new-model-of-kinship or wtv). And this per-haps is the final ball and chain that weds you to the market that you can all expect to find waiting if you pursue any sort of negative path. I hope that reading this will make you less surprised than I was when I arrived here.

Endnotes

1 This follows up on many arguments offered in *Notes on Conceptualisms* by Rob Fitterman and Vanessa Place (NY: Ugly Duckling Presse, 2009). Two quotes from this in particular are relevant: "What is an 'impure' conceptualism or post-conceptualism in writing? A post-conceptualism might invite more interventionist editing of appropriated source material and more direct treatment of the self in relation to the 'object,' as in post-conceptual visual art where the self re-emerges, albeit alienated or distorted (see Paul McCarthy)." (24)

"We are painfully aware that Conceptual Art was termed nearly half a century ago, and much of what we address might equally be called post-conceptual or neo-conceptual (to borrow terms from the visual arts)." (12)

2 See Jameson on Bob Perelman, first published as "Postmodernism, or the Cultural Logic of Late Capitalism," *New Left Review* 146, July-August 1984, 53–92. Jameson's essay appears in the volume to which it lends its name, *Postmodernism, or The Cultural Logic of Late Capitalism* (Durham: Duke University Press, 1991), 1–54.

3 Daniel Tiffany, "Cheap Signaling," *The Boston Review*, August 2014 <www.bostonreview.net/poetry/daniel-tiffany-cheap-signaling-class-conflict-and-diction-avant-garde-poetry>.

4 Queer structuralism and queer conceptualism: Judith Jack Halberstam—*Gaga Feminism: Sex, Gender, and the End of Normal*; Kate Durbin—*Gaga Stigmata* <gagajournal.blogspot.com>; David Joselit—*After Art*; José Muñoz—*Cruising Utopia*; Lee Edelman—*No Future: Queer Theory and the Death Drive*.

5 Recent arguments about affect and irony in new poetry: Marjorie Perloff on Recent Lyric <marjorieperloff.com/stein-duchamp-picasso/poetryonthebrink/>; Eileen Myles on Perloff <www.thevolta.org/ewc29-emyles-p1.html>; Matvei Yankelevich on Perloff <lareviewofbooks.org/essay/the-gray-area-an-open-letter-to-marjorie-perloff>; Drew Gardner on Flarf <www.bostonreview.net/poetry/drew-gardner-flarf-life-poetry-affect>; Keston Sutherland on conceptual poetry <afieryflyingroule.tumblr.com/post/49378474736/keston-sutherland-theses-on-antisubjectivist-dogma>; Cecilia Corrigan on *I'll Drown My Book* <jacket2.org/reviews/drowning>.

6 Brian Kim Stefans gives a good summation of the differences between conceptual poetry and Language poetry, and suggests the ways in which conceptual poetry and speculative materialism (a constellation of philosophers following Žižek, Badiou, and Laruelle reach non-phenomenological, often scientific, approaches to 'the real'): "The play of the referent—the polysemeity of the sign as valorized in Language poetry ... is not the goal of these writers, so much as the formation of a radical new form of indexicality through which the reflexive property of objects—that they always already equal themselves—will come to supersede or compensate for that ineluctable property of words, which is that they never equal what they are pointing to. Letters and words treated as numbers in turn create equations out of their textual structure; letters and words both buttress them and comprise them. The work of literature itself forms, then, a sort of proof. ... Fiction and poetry are now able to make statements about reality, albeit speculative ones, which are based not on journalistic observation but rather on the integrity of mathematical thinking, however etiolated it might be. ... The aim of speculative realists—and this is where they intersect with the apparently non-realist, highly structured mode of [conceptual writers] ... is to create a description of this great outdoors (a metaphysics, even if this term is often disavowed) without the language of description, which would reduce this outdoors to mere thought ... rather than wallowing in the impasse of "postmodern" relativisms [and here postmodern/poststructuralism à la Language poetry is being referred to]—that there is no knowledge of the world untainted by cognition or conceptual categories, and hence that all we can ever know is the language of knowledge—these recent works are comfortable with the ultimate impossibility of divining essences or absolutes through thought. In fact, these works bracket the subjectivity of their "characters" (when they have them) in favor of subjecting readers directly to the work and putting objects for study in their hands, both literally and figuratively. In some more extreme cases, these writers even imagine a future in which literature will not be made by or for humans at all—what Christian Bök has a dubbed a 'robopoetics.'"—Brian Kim Stefans. "Terrible Engines." *Comparative Literature Studies* 52.1, 2014, 139-83.

7 Philosophy discussed here: Eleanor Kaufman, "The Desire Called Mao" <www.faculty.virginia.edu/theorygroup/docs/kaufman.desire-called-mao.2008.pdf>; Christopher Norris, *Badiou's 'Being and Event': A Reader's Guide*; Geoff Boucher, *The Charmed Circle of Ideology*; Levi Bryant, Nick Srnicek, and Graham Harman, *The Speculative Turn*; Ray Brassier, *Nihil Unbound*.

8 History of poetry and art discussed here: *Postmodern American Poetry: A Norton Anthology*, ed. Paul Hoover; Sianne Ngai, *Our Aesthetic Categories*; *Against Expression: An Anthology of Conceptual Writing*, ed. Kenneth Goldsmith and Craig Dworkin; *GaussPDF* <www.gauss-pdf.com>; *Troll Thread* <trollthread.tumblr.com>.

9 <poetrywillbemadebyall.ch/>.

10 Claire Bishop, "Digital Divide," *Artforum*, September 2012.

11 Kareem Estefan, "Deep Code," *Art in America*, September 2013.

12 Kareem Estefan, "A Cute Idea," *The New Inquiry*, 2014 <thenewinquiry.com/essays/a-cute-idea/>.

13 Here one must note the difference between closely read incisive sophisticated deconstructive readings and open-ended sloppy postmodern indeterminacy: "Indeed, I would venture to define this as the hallmark of a properly deconstructive reading as opposed to one which exploits a vaguely Derridean rhetoric of différance or, on occasion, a quasi-Gödelian rhetoric of undecidability. The former kind of reading entails a claim to discern or detect certain non-manifest textual structures—most often logico-semantic structures leading to a point of classically irresolvable aporia or contradiction—that are demonstrably there in the text under scrutiny even though they had hitherto passed unnoticed when subject to other, less exacting modes of analysis. The latter kind, conversely, makes liberal use of those terms and their various cognates but does so in a loose and approximative way, or through a broadly analogical (even metaphoric) mode of thought that lacks anything remotely comparable to Derrida's practice of close-reading as a form of immanent critique." Christopher Norris, *Derrida, Badiou and the Formal Imperative* (London: Continuum, 2012), Kindle edn., 90.

For Badiou and Derrida there is certainly an undecidability which goes to the point that the truth always eludes the current grasp of knowledge but which nonetheless can be discovered through certain formal procedures. This follows Kurt Gödel, but not the Gödel who abandoned work once he discovered that truth eludes knowledge, but the one who worked twice as hard to demonstrably prove this fact:

"This was Gödel's famous undecidability theorem to the effect that any formal system of sufficient complexity to generate the axioms of (say) elementary arithmetic or first-order logic could be shown to contain at least one axiom which could not be proved within that system or by using its own logical-conceptual resources.[78] What is strange about this is that the theorem is itself set out and proved by means of a highly complex and extended formal-logical sequence of argument which cannot but depend upon just those resources that it shows to fall short of such probative warrant or ultimate demonstrative force. Gödel espoused an objectivist and classical—in this context what amounts to a Platonist—approach since he thought that it offered the only way to save his argument from just that charge of manifest self-refutation as well as affording the only adequate ontology and theory of truth for mathematics and the formal sciences. Unless it were the case that there existed truths beyond the limits of purely formal demonstration or proof, and unless our minds could have access to them by some non-empirical means, then there could be no accounting for our grasp of a theorem which requires such a highly elaborate structure of logico-mathematical argument yet the truth of which, on its own submission, cannot be derived by any purely axiomatic-deductive or rigorously formalized means."—Norris, 89.

Likewise, Language poetry had an aversion to the idea of the open-ended indeterminism that had marked something like Fluxus and conceptual art (especially in their first reading by Perloff) because they too had a consistent formal commitment to rigor, negative dialectics, philosophy, Marxism, and poetics.

In contrast, conceptual poetry abandons any recourse to the accessibility of the truth and therefore just gives empty reams of knowledge, a dumb indeterminacy associated with Jamesonian postmodernism. But post-conceptual poetry by inserting the possibility of the truth and the real back into the empty forms of postmodern vapid indeterminacy given by conceptual poetry points to a way in which that madness might take hold, in an sharp indeterminacy that threatens to abandon the formal procedures, and eschews knowledge, formal rigor, and work, in favor of a boundless, raw truth. This is a babbling play of signifieds that has subtracted the power of the chart and the signi-

fier, and bears much in common with the Foucauldian non-relational homoeros of Leo Bersani. This is done not in order to level the playing field (to give the mad subaltern abject woman a 'voice,' which is the task of a relatively conservative writer like Kate Zambreno) but to actually abandon the playing field altogether.

14 Johanna Drucker, *Sweet Dreams: Contemporary Art and Complicity* (Chicago: University of Chicago Press, 2005).

15 "A Life in Theory: Sylvère Lotringer with Joan Waltemath," *Brooklyn Rail*, September 2006. <www.brooklynrail.org/2006/09/art/a-life-in-theory>.

16 Jay Sanders and J. Hoberman. *Rituals of Rented Island: Object Theater, Loft Performance, and the New Psychodrama: Manhattan, 1970-1980* (New York: Whitney Museum of American Art, 2013), 36.

17 The real-of-the-real is romantic sheerly affective poetry (the id), romanticism and modernism and certain 'weak' postmodernisms (such as Hannah Weiner or John Wieners).
 The real of the imaginary is the real of egotistical fantasy (often self-conscious and self-critical): flarf, strong postmodern/poststructuralist poetry (such as the canonized members of Language poetry), some post-conceptual poetry. Of course, poetics of the imaginary are closer to 'normal life' of the ego than the other two, as Drew Gardner has recently expressed regarding Flarf: it is a poetics of everyday life. Flarf and some post-conceptualisms, like Language poetry, risk falling into the real-of-the-real whereas conceptualism for the most part has a blockade against this. Cecilia Corrigan's work risks this fall though it is astutely held afloat by self-conscious, self-critical wit. It is its own bird but nonetheless shares certain affiliations with Language and Flarf—but not so much (besides being generationally symmetrical) with post-conceptualism. Trisha Low's post-conceptual narcissism comes to mind: the messy 'mirror stage' of ego fabrication, imitation, differentiation, and fantasy takes place. Lacan rightfully aside, what Low calls this, among other things, is the 'not-not me': a regurgitated, messy, mixture of cultural fantasies. Indeed, it is unclear the degree to which what post-conceptualism is able to do is all that distinguishable from Flarf or Language poetry. Nada Gordon: "I do not privilege, obviously, appropriated writing over a more Romantic interiorly generated writing...in fact, the sort of writing that most intrigues me is that which...performs a kind of pavan between these two modes, because that is how I experience the world, as input and output gracefully and/or shockingly affecting each other."—*I'll Drown My Book*, 153.
 The real-of-the-symbolic (the matheme, the real discovered through and by the letter alone): conceptual poetry, post-postmodernism, speculative materialism, the end point of Žižekian-Badiousian readings of Lacan (which tend to deny access to the real-of-the-real, and finds the real-of-the-imaginary as something to be traversed so that one receives the formal clarity of the real-of-the-symbolic).
 Some reasons to flee the real-of-the-imaginary.
 Neurotic quotes from my father's book *Recalculating* (Chicago: University of Chicago Press, 2013): "Ideology's veils are imaginary; the freedom from these veils delusional" (176). "Poets are fakers / Whose faking is so real / They even fake the pain / They truly feel" (3). "Poetry fakes nothing actually" (98). "In the viscosity of process, the

end never arrives," "Speak truth to truth," "Poetry is difficulty that stays difficult" (4). "Overcome by nostalgia for the future / Bent over with a dry panic / I clung distractedly / To the promise of the present" (53). "In starts and flits / We dart and flip / With quirks and fits / Mirroring mist" (101). "The imaginary ride that actually works" (89). "Even when it's over it's not over" (92). "I am a Jewish man trapped / in the body of a Jewish man" (129). "Send me away / I've never been there" (156). "Here where I find you, here will I lose you" (171).

In these quotes, you can see not only representation of the stuckness of ego-based imaginary life, but also its mirroring murkiness, and most crucially its immanence: the inability to escape: to find a transcendental elsewhere. This can lead some to wish to retreat into the symbolic (a return to the iron clad signifier à la Place) or to retreat into the real (new sincerity, new romantic lyrics).

If Bernstein might seem gleefully trapped by the ego and its linguistic interpellation, by contrast, Badiou, Žižek, and Place turn against the linguistic constructivism of poststructuralism/postmodernism. For them, the subject of truth and the subject of history stubbornly resist the ideological misrepresentations and immanent materialisms of the Imaginary. The truth, instead, is always a transcendental outside, that can be determined only vis-à-vis formulaic formalistic procedures that lead to those revolutionary moments of change called 'events' (they are more restructuralists then poststructuralists). Therefore, the one with the power to know and to decode and to change a given situation is always the one who is the master of formula (the concept, the truth-procedure), rather than someone with an intelligent feel for 'everyday life.' Althusser and Lacan are exemplary heroes of postmodern linguistic constructivism, as well as for Badiousian-Žižekian post-postmodernism: they are read quite differently by each. The key difference is found in their conflicting readings of Lacan's imaginary. The constructivists (like Bernstein) are happily relegating everything to imaginary swerves and dips, while the Badiousian-Žižekians (like Place) are always attempting to traverse imaginary idiocy. Post-conceptual poetry, as a whole, has not shown its face on this issue yet. While it is possible that they might return to a delightful imaginary idiocy (like Bernstein and flarf), they might also increase the compulsory formulaic traversals of the imaginary (à la Place).

The zany (as Sianne Ngai terms it), a category that includes my own video work, Ryan Trecartin, and Kiki (Mx. Justin Vivian Bond) appears, in some ways to be a return to a delightful imaginary. But, I think it has grown increasingly clear that Trecartin's zaniness brackets off (and traverses) any youthful exuberant imaginary so that it can be used for a very very very cool, slick style. And Kiki's turn into Mx. Justin Vivian Bond suggest drippy sincerity and queer essentialism that has sort of thrown all zaniness to the trash. As for me, I'm trying desperately to make something 'special' out of an over-abundant load of coincidences and conflicts, in as pure and as rigorous a way as possible. But also I'm trying to preserve as much of my own melancholic introverted commitment to writing, performing, and making videos as I possibly can in the face of my own compulsory drive towards institutional success and attention-whoring.

18 "Non-philosophy, in its most basic sense, is an attempt to limit philosophy's pretensions in the name of the real of radical immanence. It is an attempt to shear immanence of any constitutive relation with the transcendences of thought, language, or any other form of ideality, thereby revealing the Real's absolute determining power—independently-of and indifferently-to any reciprocal relation with ideality. It is true that

numerous philosophies have proclaimed their intentions to achieve immanence, with a number of them going to great lengths to eschew all ideality and reach a properly immanent and realist beginning. What Laruelle reveals, however, is that all these previous attempts have been hindered—not by their content, which is overtly materialist, but rather by their very form of philosophizing. It is this form that Laruelle gives the name of Decision. Even materialist philosophies are turned into idealisms by Decision making them reliant on a synthesis constituted by and through thought. Put simply, through Decision, philosophy has continually objectified the Real within its own self-justified terms."–Nick Srinek, "Capitalism and the Non-Philosophical Subject," in *The Speculative Turn: Continental Materialism and Realism*, ed. Srinek, et al (Melbourne: Re.press, 2011), 165.

Laruelle wants a non-philosophy that stops 'deciding' that stops 'thinking' and just presents the real Real, with a neutral uncontested symbolic jargoned framework. This is a perfect parallel to queer structuralism.

19 Benjamin Buchloh, "Farewell to an Identity" in *Artforum*, December 2012.

20 Christopher Glazek, "On Ryan Trecartin" in *N+1*, Sept. 2012.

21 Keith J. Varadi, "The Bubble Gum Dirge," in *Artfrum*, February 2014 <artfrum.com/post/76290300612/the-bubble-gum-dirge-by-keith-j-varadi>.

22 *Corrected Slogans: Reading and Writing Conceptualism*, ed. Lucy Ives (New York: Triple Canopy, 2013), 95.

23 William S. Smith in *Corrected Slogans*, 111.

24 Joselit, *October*, No. 142, Fall 2012, 80.

25 Queer structuralism bears resemblance to the trend of new structuralism found in French philosophy through Badiou's belligerent ontological turn against the reliance on Kantian epistemology and Wittgensteinian linguistics, in favor of establishing universal and meaningful (rather than chaotic and splintered postmodern) post-postmodern criteria. Also, the structuralists of *October* art criticism (that came to prominence in the 1980s but still holds heavy power in the art world) also come into play, for also rejecting the notion of splintered linguistic relativism, in favor of abstract reasonings and charts, i.e., structural knowledge that, as long as it is being carried out by the most advanced specialists in the field, will always be the most correct and the most avant-garde. Yet the returns to structuralism over and against poststructuralism does not mean merely the production of 'dry' works, but it also means a return to an object-oriented ontology where the subject is bracketed out so that one can romantically and melancholically experience the being-of-objects, a wet structuralism that one can find in the more depressive ends of modernism, such as late Virginia Woolf.

It is a mistake to think that knowledge alone is what *October* is after; rather they are after a knowledge that is supported by a Badiousian truth that is marked by its transcendence of knowledge, but can only be quantified and faithfully adhered to through knowledge. So Badiou and *October* follow Descartes in appreciating the cogito and rational mind, and yet this is only made possible by transcendent events (such as

the October Revolution). Yet Badiou and *October* must give deference to Lacan, who devalues the cogito by showing that although Descartes has a rational knowledgeable structured ego, it just comes to fill a lack of ego, it rests on a 'nothing' that is outside of knowledge/rationality/structure. Finally it is Barthes' structuralism, which like Lacan and Badiou and *October* orients structure around certain lacks (so-called 'punctums'). These punctums, radical avant-garde events, and lacks are offered as a way to defend and justify the hierarchical dryness of queer structuralism.

26 Jeffrey T. Nealon, "RealFeel: Banality, Fatality, and Meaning in Kenneth Goldsmith's The Weather" in *Critical Inquiry* 40:1, Autumn 2013,109-132.

27 Eileen Myles, "Painted Clear, Painted Black, " in *The Volta*, May 2013. <www.thevolta.org/ewc29-emyles-p1.html>.

28 "An Interview with Trisha Low" at *Book Slut*, Dec. 2013 <www.bookslut.com/features/2013_12_020428.php>.

29 This is not a real quote from Vanessa Place.

30 Ibid.

31 Todd McGowan, *The End of Dissatisfaction: Jacques Lacan and the Emerging Society of Enjoyment* (Albany: SUNY Press), 109.

32 Vanessa Place interviewed by Andrea Quaid in *Bomb*, March 2012. <bombmagazine.org/article/6466/>.

33 David Micah Greenberg, "When That Becomes This", in *Boston Review*, March 2012. <http://bostonreview.net/poetry/david-micah-greenberg-comparison-politics-poetry>.

34 Žižek, "Against the Populist Temptation" <www.lacan.com/zizpopulism.htm>.

Hipster Handbook
A Brief Timeline

1994: English-based poet Caroline Bergvall pioneers "Performance Writing" (intersection of visual arts, poetry, performance, and installation), at the Dartington School of Arts: Her earlier work brings a less ballistic, less heroically masculine approach to sound poetry. Since the 2000s she has also channeled her texts through the sound patterns of Middle English and Old English and their Nordic echoes. Her performance poetry aesthetic deals with the history of English and with a strong framing. Along with performance-poet Tracie Morris and Canadian poet Rachel Zolf, Bergvall's meeting of hybrid forms with a queer political consciousness has had a wide influence particularly for political-poetical collectives like Belladonna, and all three have provided a stark contrast to the typically Goldsmithian conceptual poetry, which has sometimes been critiqued for having masculinist or politically frivolous tendencies.

1999: *Ambient Stylistics* by New York-based Tan Lin: poetry should be easy listening as reflected in his *Seven Controlled Vocabularies / The Joy of Cooking* (2004). Lin also sets a precedent for video/text installations that have influenced Danny Snelson and others.

2000: *Fidget*, by New York-based Kenneth Goldsmith, takes another turn toward an easy-listening conceptual conceit, where there is linguistic, sonic and thematic consistency. This was a shift from his mid-90s work *No. 111.2.7.93-10.20.96*, which is a densely epic-collage from many, extremely varied sources. After *Fidget* and *Soliloquy*, Goldsmith moved to a stricter model of Conceptual Poetry and Uncreative Writ-

ing, for which appropriation from a single source is key. From 2004, Goldsmith has been a lecturer in the Creative Writing Program at the University of Pennsylvania; students have included Steve McLaughlin and Trisha Low. He has endorsed and supported many artists and writers that range from Ryan Trecartin to Miriam Gonzalez. Goldsmith started Ubuweb in 1996 as an archive for conceptual poetry, as well as sound art, avant-garde film, video art, and the historical avant-garde.

2001: *Eunoia*, by Canadian poet Christian Bök, is a constraint based work, which leaves room for wit, narrative, ingeniously original composition, and aesthetic pleasure, a stark contrast to post-9/11 appropriation approach of Goldsmith's Conceptual Poetry or Tan Lin's Ambient Stylistics. *Eunoia* is a virtuosic word-game constraint (a kind of Oulipian game of scrabble). His students and peers include Derek Beaulieu and Jordan Scott, who carry on his virtuosic-constraint model.

2001: Gary Sullivan, Nada Gordon, Drew Gardner, Katie Degentesh, and others started the Flarf email list. Flarf was Internet poetry of the early 2000s that thought Google search results made super cool poetry (that sometimes verged on frat humor) but was still a small intelligent group of avant-garde poets invested in poetic lineage. Also, publishing of *Swoon* (made up of romantic emails between Sullivan and Gordon).

2003: *Reading the Illegible* by Craig Dworkin: Obsessively close readings of literally illegible works by language poets and visual artists such as S. Howe, MacLow, Broodthaers, Smithson, Cage, McCaffery. Continues to write incisive commentaries on conceptual and younger conceptual practices. Snelson studied with him as an undergraduate at Princeton. Dworkin studied, like scholars Brian Reed and Michael Golston, with Marjorie Perloff.

2003: *Deer Head Nation* by K. Silem Mohammad: early Flarf, important, data mining work. The title poem is based on using the language generated on a Google page for the search term "deer head nation."

2004: *Metropolis* XXX by Rob Fitterman—marks his turn from Creeleyesque post-Language lyric to his "Identity Theft" aesthetic (though his previous book featured his first 'directory' list of shopping center store names). Goldsmith praises him for doing the dandy in the hollow landscape thing. I wouldn't go so far as to say it's an anti-sublime sublime or a stuplime but I would say it's an anti-redemptive redemption. Fitterman and his champions at that time followed the Christopher Nealon ideal that post-language-poetry camp could create a new kind of affective identification with the marginal, junky, and obsolete. However, they uncoupled camp from Nealon's progressivist Leftist politics, only to revivify camp's claims to aesthetic inventiveness and critical self-reflexivity. Meanwhile, militant Leftists attacked Fitterman's camp for being totally vapid and lacking any value whatsoever.

For my note on this issue as it plays out in Goldsmith and Warhol see below (from my piece "Forget O'Hara" in the *Boston Review*, 2013):

> However, Goldsmith's work could not succeed if it were merely empty and meaningless. Rather it seems to merge the meaningless and the meaningful in a way that fits the billing of Hal Foster's concept of traumatic realism, exemplified by Andy Warhol (who is Goldsmith's single biggest influence). Foster explains that Warhol's brilliance lies in being at once, 'referential and simulacral, connected and disconnected, affective and affectless, critical and complacent, [feeling and unfeeling].' Thus, Warhol realistically illustrates the mind of the traumatic subject. This theory refutes the two dominant readings of Warhol: as either subversive and affective (Barthes, Foucault, and Deleuze all made this claim) or neoliberal and empty (as Baudrillard argued). Foster's Warhol manages to reconcile piercing bloody subversion with vapid neoliberal complicity, as well as deconstructive irony with queer romantic affectivity. In visual art this Warholian resolution has been milked sufficiently dry: creating works that critics and audiences alike can go home titillated but not offended by, since the work is at once so hot and so cold that it leaves

us with works that are lukewarm. What is so striking about this debate, as it has emerged so prominently in recent poetry discourse, is how quick critics are to pick a side, calling conceptual poets like Vanessa Place or Kenneth Goldsmith either affectless, empty, and vapid or meaningful, emotional, and subversive. Perhaps the delay in seeing this work through the lens of traumatic realism comes from estrangement of poetry criticism from art criticism, with each taking turns at lagging behind the other.

2004: *A Family Finds Entertainment*, video by Ryan Trecartin. (He, like Goldsmith, studied at the Rhode Island School of Design.)

2006: Unofficial, as-yet-unnamed start of Alt Lit: Tao Lin's first book published, and start of *HTMLGiant* (a lit review and posting site). Alt Lit remakes Flarf so that it becomes as ubiquitous and confessional as amateur Tube pornography, and New Sincerity in pop culture, with its herds competing to have their fiction come out in mainstream publishing houses (so they can be like their hero Tao Lin) or to have a huge amount of Twitter followers. Goldsmith remarks that it is "marked by direct speech, expressions of aching desire, and wide-eyed sincerity." (For more on New Sincerity see my review, starting on page 161, of Dorothea Lasky's book *Rome*.) Alt Lit is a fashion brand name and the people involved seem to have little to no sense of the history of poetry. "What's Flarf?" Mainerstream hipster culture finds this increasingly infantile and "bro-ey" and will dismiss it especially because of alleged accusations involving male Alt Lit writers being creepy. Meanwhile, female Alt Litters Melissa Broder and Miriam Gonzales will probably have long uncontroversial careers with or without separating themselves from the label. More controversial is Marie Calloway, who wrote takedowns of various men in publishing (including Tao Lin) and graphically describes brutal sex encounters on Craigslist. Though less invested in any sort of writerly 'craft' than post-conceptual poet Low, she similarly rethinks the sentimental frame from which women are supposed to write about trauma. This is consonant with a feminist rethinking of overlooked works and forms by women, in tandem with writers like Kate Zambreno. This rethink-

ing makes the typically ignored writing of such crazy or colloquial or affective female diarists as Dorothy Wordsworth into art on par with the guys (if not even better). This frame shift in women's literature also crucially happens in the work of conceptual poet Vanessa Place, who appropriates rape victim testimonies in *Statement of Facts* (2010). More examples include: post-conceptual poet Divya Victor, who, like Low, embarks on a Kristevaean repurposing and collaging of the medical and sticky hysterical "female" babble in *Things To Do With Your Mouth* (2014). Kim Rosenfeld's *Trama* (2004) and the 70s/80s works of Kathy Acker and the 80s/90s New Narrative writings (particularly the *Cunt-Ups* of Dodie Bellamy and Kevin Killian's AIDS-mixed-with-Italian-horror-imagery-memoir-poems *Argento Series*) set a precedent for messy feminist appropriations.

2008: *The Fame* (Lady Gaga's debut album).

2008: "Conceptual Poetry and Its Others" conference at the Poetry Center of University of Arizona (Tucson), organized by Marjorie Perloff, with headliners Bergvall, Bernstein, Bök, Dworkin, Goldsmith, Morris, and Cole Swenson. Laynie Browne made a feminist intervention at the event; later Browne—who is not a conceptual poet—edited a women's conceptual poetry anthology with Place (who was also a respondent at the conference), Bergvall, and Teresa Carmody. This occasion marks the conversion of Place to conceptual poetry, though she had already written a debatably conceptual work *dies a sentence* in 2006.

2010: *Statement of Facts* by Vanessa Place.

2010: *Gurlesque Anthology*, edited by Arielle Greenberg and Lara Glenum. Combining aspects of feminism, burlesque, sexual display, lyricism, and the grotesque, while welcoming pop cultural complicity.

2011: *Against Expression*, edited by Kenneth Goldsmith and Craig Dworkin: anthology of conceptual writing that debuts Trisha Low's work.

2012: *Unoriginal Genius: Poetry by Other Means in the New Century* by Marjorie Perloff includes, as its final chapter, one of the first academic accounts of the work of Goldsmith.

2012: *Gauss PDF* founded, Ben Fama's *Mall Witch* published by Wonder Press: post-conceptual poetry emerges.

2012: *Gaga Feminism: Sex Gender and the End of Normal* by Judith Jack Halberstam is a book of queer theory that celebrates Lady Gaga.

2013: First major works by self-dubbed post-conceptual poets, including Trisha Low's *Purge* and Josef Kaplan's *Kill List*.

Taxonomy of Younger Post-Conceptual Poets

The Self-Titled Post-Conceptual Poets

Self-defined next of kin to Goldsmith, Fitterman, Rosenfeld, and Place, many of whom studied at SUNY-Buffalo graduate program (Joey Yearous-Algozin, Holly Melgard, Chris Sylvester, Steve Zultanski, and Divya Victor, whose work has been centrally located on trollthread.tumblr.com), though Sophia Le Fraga and Trisha Low studied undergrad with Fitterman and Goldsmith respectively. (Some more varied work is featured on Le Fraga's imperialmatters.com.) They mostly have a nihilistic philosophy that decouples poetry from redemptive activism (a certain amorality or apoliticism is a conceit of Goldsmith, Fitterman, and Place). Formal tactics commonly employed include erasures and transcriptions (i.e., Yearous-Algozin transcriptions of semi-hysterical phone messages family members left for his girlfriend Melgard [2014], and his erasures of Larry Eigner). Steve Zultanski's *Agony*, a microscopically constrained confessional poem (heavily indebted to Goldsmith's *Fidget* though taking its specificity ad absurdum to scientifically technical limits), which came out in 2012, has been a kind of critical benchmark for the group. Related to this direct treatment of the gross quotidian is Diana Sue Hamilton's "Dear Shit Advice Columnist."

Mostly these folks are allergic to Alt Lit because it is déclassé, banal, mainstream, and ubiquitous (as well as oriented towards commercial fiction). They have an investment in the lineage and history of

avant-garde poetics, and do work that can take on epic-lyric form (including Josef Kaplan's fascinating *Shoot Kids in the Head*) or else deals with figures like Gertrude Stein (Melgard) or Eigner (Yearous-Algozin). Lanny Jordan Jackson's work, as Le Fraga's, is whimsical and employs video and other forms. There is a tendency in the blurbing around these folks to suggest that they are inventing the wheel, "bringing the lyric into the twenty-first century," when often they are repeating gestures from Flarf or Language poetry. This myopia is due to comparing the work, in a bubble, to the sometimes-strict parameters of conceptual poetry.

Despite post-conceptual poetry's allergy to Alt Lit, Goldsmith has been quick to endorse many Alt Litters (especially Steve Roggenbuck). Indeed, Alt Lit has aesthetic strategies that very much fit the post-conceptual mold: it's just its poethical-historical underdevelopment that separates it. Fitterman has been loyal to the self-identified post-conceptualists (see his book *Collective Task*, 2014, a collaborative enterprise with this younger bunch).

At times, looking through the works of this group as a whole, but especially the Buffalo contingent, the philosophical stakes one finds in Place or the humor one finds in Goldsmith or the virtuosity one finds in the Bergvall/Dworkin/Bök School is absent. Instead, there is something new: a dreary, bleak blankness to this work that can give one pangs of nausea. (Though philosophical stakes are present in Low and Kaplan, and humor/pizzazz can be found in Le Fraga and Jackson.) Perhaps, to quote one of their titles, this is a "white trash" aesthetic that counters the vibrancy of trash aesthetics made popular by John Waters—*like I'm just gonna scan lotto tickets and upload that as a pdf online and see if the university, who funds our work, will pay us for the lotto losses*—that make the group seem like they might be characters from Harmony Korine's *Gummo* gone to grad school. (Korine has articulated the difference between his early work and that of Waters, though his recent *Spring Breakers* seems to take the Wonder aesthetics discussed below). It is, then, boredom-beyond-boredom, not a redemptive/interesting Zen ironic/stupid sublime, which one has always gotten from the principal conceptualists in art and poetry

(from Duchamp on). That is to say, there is no Ngai or even Perloff, who can justifiably pull out Kantian adjectives that flatter this work; rather it possesses a wallowing self-deprecating slacker mentality that is only astounding in proportion to how much talent and labor you think is being wasted. This is what I mean by death of work (death of the reader).

Troublingly, this book is called *Notes on Post-Conceptual Poetry*, despite the fact that the group claiming this title is not the primary focus. And if at times I stumble into the Perloffian position of elevating select individuals (Low) and ignoring constellations, forgive me. I'm not writing this book to deliver a who's who in today's poetry but to create the sensation of being lost in the burbling cauldron of emerging social formations.

LA Conceptualists

Everyone feels the poets are ignored and misunderstood in LA, but then feeling marginalized by New York and San Francisco is an LA art thing. One discipline no longer ignored in LA, though, is the visual arts. CalArts has churned out art world superstar after superstar. Of principal importance to the poets discussed here, CalArts, starting in the 70s, was the site of the wacky conceptualist/visual artist John Baldessari whose smart hip détournements bordered the visual and the verbal and often resembled Lang Po in its deconstructive auto-referential ironies. But the words were always blown up super big so they could sell as art works. Joseph Mosconi's magazine font, colorized words (of what he ate or metal band lyrics) quite clearly continue this tradition.

Place is the most famous conceptual poet in LA and she runs with her partner Teresa Carmody, Les Figues Press, which publishes a lot of younger conceptualists, often with an LGBT or feminist bent, including Divya Victor (as well as, the first-generation conceptual poet, Kim Rosenfeld).

New Narrative poetry (including superstar fellow travellers Kathy Acker and Dennis Cooper), the West Coast queer writing complement to Language poetry, was gothic, punk, and well, digressively narrative. It has yet to fully get its dues, though an anthology, edited by Kevin Killian, will be out soon. But certainly the assisted conceptual conceits of New Narrative author Dodie Bellamy (*Cunt-Ups*) are crucial to the messy-I feminist conceptual aesthetic. Bellamy's recent *Cunt Norton* (2013) came out with Les Figues. Another New Narrativer with a book from Les Figues is Matias Viegener, a book that remakes Joe Brainard's *I Remember* through Facebook statuses of 25-element lists (*2500 Random Things About Me Too*).

Viegener teaches at hotspot CalArts where he works along with the verbal-visual virtuoso Christine Wertheim to teach many of the younger-conceptual-poets-to-be. Harryette Mullen, who teaches at UCLA, is another important figure for influencing constraint-based virtuosic work in the lineage of OuLiPo. CalArts grad Amanda Ackerman has been doing work through literary-performance collectives (such as The Unauthorized Narrative Freedom Organization), which stage events blurring the borders between poetry reading, gallery exhibits, creative workshops, and secretive constraint-based happenings. Janice Lee's *Damnation* is a strong virtuosic work by a younger conceptual poet: a handmade chapbook that creates a visual-verbal ekphrasis for Bela Tarr's film of the same name.

Younger conceptual poets working in the monumental precedent set by Place include my publisher Mathew Timmons, whose epic work *CREDIT* (2009) is "an 800 page, large format, full color, hardbound book–the longest, most expensive book publishable through the online service, lulu.com." Timmons also wrote *The New Poetics*, which collages web texts to produce manifestoes for new modes of thought: New Art, New Blood, New Christianity, etc. Harold Abramowitz's *Dear Dearly Departed* (2008), one long and heart-wrenching paragraph brings to mind the fact that Place also wrote a very long sentence as a book called *Dies*.

Important to note, as well, is that Goldsmith's early hits (*Weather, Traffic, Sports*: monumental transcriptions) were published in LA by the slightly younger conceptual poet Ara Shirinyan. Shirinyan also works in the monumental tradition, appropriating tons of phrases from the net that start with "[country name] is great" creating a work that extends to three volumes (*Your Country is Great*, 2008).

Make Now (Shirinyan), Insert Blanc (Timmons), and Les Figues (Place/Carmody) each have substantial lists of publications. I won't pretend I've delved deeply into their lists. Nor am I able to contrast the West and East coast post-conceptualists. Brian Kim Stefans has argued that the difference is the LA poets' emphasis on production. I can see that with Timmons and Kate Durbin and Place, but most of conceptual poetry is about big productions so I can't quite parse that one. Definitely the Buffalo group has a kind of slacker nihilism that I don't see in LA. But on the East Coast Goldsmith and the Wonder group seem to be overlapping heavily with the brighter poppier slap-happy overproduction sensibility of the LA younger conceptualists. They literally overlap with LA-based Kate Durbin who has published with Wonder. Known in part for dressing up in DIY costumes that resemble Lady Gaga in their pop outlandishness, her poetry appropriates dialogue from television and pop culture but usually in a highly modified and traditionally poeticized or narrativized form that makes it consonant with the gurlesque aesthetic.

The Wonder Kids

The Wonder Kids follow the precedent of Frank O'Hara, Kenward Elmslie, Wayne Koestenbaum, and Kevin Killian (blending fashion, pop culture, the faggy quotidian, and the art world into poetry) and flavoring Flarf and the Gurlesque with Miami metrosexual hipster summer frivolity. Youngish Bay Area poet Brandon Brown is also an important precedent for the group: talking seriously (poethically) about Kanye West and Taylor Swift.

In the 2010s, New York-based metrosexual Ben Fama quickly passed this style down to Andrew Durbin and together they run Wonder

Press, which has since published Kate Durbin (not Andrew's sister) and the New Narrative, Bay Area poet Killian. Durbin with incredible speed and efficiency created a cluster of gallery artists who share his taste—a younger variant of the clusterfuck aesthetics of Bjarne Melgaard and Thomas Hirschhorn but more delicate, pink, and sweet (post-camp, hyper-camp)—such as Alex Da Corte, who designed his book cover and Jacolby Satterwhite, who Durbin wrote a catalogue essay for. In the art world, the person who comes closest to this style is Ryan Trecartin, especially his sculptural work. Other similar stylists include Morgan Parker (see her poems about Beyoncé) and LaTasha N. Nevada Diggs (see her book *Twerk*). In pop culture, there is the hyper-camp post-feminist stylings of Nicki Minaj, Katy Perry, Iggy Azalea and Harmony Korine's *Spring Breakers*. And more importantly: young and emerging queer rappers.

Also: see Gaga's *Art Pop* album and cover by Jeff Koons, which shows that for millennial art, the direction of Pop Art is being reversed—the weird iconic ironic borrowings of Pop Art are still there but in place of Pop Art's cool distance, Gaga uses appropriation to create a very real and sincere identity. That's what makes Gaga the poster girl for queer essentialism despite her ironic drag. Think here of the shift from Judith Butler's 90s hipster manifesto *Gender Trouble* to her 00s bible *Bodies That Matter*. Jerry Saltz is getting at this when he mentions Gaga along with her artist pals Marina Abramovic and Koons, along with Kanye, as examples of a New Uncanny, in which the celebrity claims to be keeping it real in a way that is alienating and virtual, yet enchanting. Saltz 'likes' this stuff a lot and blurbed Kate Durbin's book for Wonder press.

Experimental queer filmmaker Bruce la Bruce recently complained about the more famous manifestations of this style in "Notes on Camp and Anti-Camp," where he longs for the good old days of a wittier, more thoughtful, and less virtual camp. I critiqued the poethical import of such work in "Forget O'Hara" (*Boston Review*, 2013). My satiric alter ego, Leopold Brant, based on Peter Brant II (fashion dandy fed by the golden spoon of his famed Warhol collector father) parodies the strategically felicitous intersection of pop art, Marxism, queer the-

ory, fashion, and social climbing—as have many of my YouTube videos going back to 2008, including one where I critique Lady Gaga. In the majority of these works I parody the pathos of gay self-promotion. Of course, hyper-camp art always involves a great deal of self-parody, but often it risks morphing into a lax bro "keeping it real" queer essentialism. My Brant persona is, additionally, a parody of the John Ashbery School of gay male lyric poetry that is less zany than the Wonder style and centers around a newfangled bourgeois salon scene.

At times, like all works caught up in fashion, the problem of the neophilic and *basic as fuck* arises i.e., "I had the eighth most cited piece on *Hyperallergic* last year about normcore ... then I got picked up to do a piece for *T*, the *Times* fashion magazine."

Or else "that gentrified social climbing clickbaiting trend sniffing basic-as-fuck tool just wrote another blog complaining about gentrification" or "that basic-as-fuck tool just made another meme-like reductive Facebook post saying how memes are reductive when all he does is communicate through memes."

To a certain extent this is a haunting specter for all critics of the present time. Few political activists or aestheticians, even those interested in small press hermeticism, or anti-statist anarchy, are willing or interested in *not* being on Facebook, *not* subscribing to the most blatant and pathetic self-promotional and social-climbing tactics, and mostly in the end want to be in *HuffPo* following search engine optimization (SEO) conventions. Often MFA programs in art make it seem like back in the day, like the 60s and 70s, or the days of romanticism, or something, that sort of art and politics was possible . . . but today it is retrograde to attempt to make visionary or separatist works.

In general, in fact, *basic as fuck* is a problem for poetry right now as it attempts to deal with the visual arts. At worst, it can become a place for people whose attempts at 'multimedia art' and 'net art' wouldn't be able to find a sympathetic glance in an undergraduate art-world-bait visual-arts class to find a home for the same sort of tactics, but a home where much more attention will be paid to them.

Hybrid Poetry, Ashbery School, and New Sincerity
See the essay on page 161 about the work of Dorothea Lasky.

See the essay on page 161 about the work of Dorothea Lasky.

What's Gaga Got to do With It?

The fact that in November 2013, Gaga's *ArtPop* album dropped to less than stellar reception and her monopolistic dominance of the media dissolved (and gone was her main fashion director) with no single hit being comparable to even the weakest of her prior hits (and then her embarrassing Tony Bennett collab) has led many hipsters to distance themselves from her flame. She's become *the passé*; a reminder of the ephemerality of millennial spectacularism, and thus a terrifying specter for the young queer artist. As with all attempts to cleanse oneself of Alt Lit, or Trecartin, or Flarf, or Net Art, the idol smashing just suggests how powerful the idol has been. That so many artists, who a year ago were #1 fans (to the point of rendering her into a feminist Christ) are reluctant to accept being labeled as related to her now merely suggests a main tenet of Gaga's own ideology: not being able to self-critically assess one's image in the mirror—being consumed by whatever one is doing in the present—lacking an ability to account for historical precedent—pretending that your spectacular ephemeralities somehow trump the one's that came right before. Thus denying influence to Gaga makes you Gaga, since this is precisely how Gaga dealt with her anxiety of influence and the precariousness of her own spectacle, by denying influence and precariousness.

If, for whatever reason, aesthetic or ethical, Gaga did not go "far enough" whatever goes farther is subject to the same conviction that the pop artist has a utopian benchmarker to hit. Mirror this with: "Queer Theory had such pure intentions but then became compromised by institutionality, or Green Day used to be so rad." This statement primitivistically posits that original intentions are more 'pure' and that things become increasingly compromised, rather than noting the institutionally mediated and highly compromised origins of such 'events' as Queer Theory's formation or Gaga's rise to fame. What this leads to is the vapid neophilic narcissism of the present, under the delusion that the present won't be wiped out as hard as the past.

And it is precisely in disavowing Gaga that one most replicates Gaga's own tactics: the tactics of the queer hipster who must always not be the queer hipster that they are, that must smash all idols including their own, and never be caught not-not wearing the same thing twice.

If Loving You Is Wrong

If C.S. Giscombe (2,860 results) is a poet, I don't want to be a poet
If Rob Fitterman (3,620 results) is a poet, I don't want to be a poet
If Caroline Knox (4,120 results) is a poet, I don't want to be a poet
If Claudia Keelan (4,280 results) is a poet, I don't want to be a poet
If Tom Mandel (5,150 results) is a poet, I don't want to be a poet
If Ed Roberson (6,100 results) is a poet, I don't want to be a poet
If Marjorie Welish (6,110 results) is a poet, I don't want to be a poet
If Aaron Shurin (6,180 results) is a poet, I don't want to be a poet
If Joseph Lease (6,190 results) is a poet, I don't want to be a poet
If Ray DiPalma (6,490 results) is a poet, I don't want to be a poet
If Graham Foust (6,800 results) is a poet, I don't want to be a poet
If Diane Ward (7,600 results) is a poet, I don't want to be a poet
If Drew Gardner (7,740 results) is a poet, I don't want to be a poet
If Tony Towle (7,880 results) is a poet, I don't want to be a poet
If Stephen Ratcliffe (7,980 results) is a poet, I don't want to be a poet
If Stacy Doris (8,110 results) is a poet, I don't want to be a poet
If Katie Degentesh (8,260 results) is a poet, I don't want to be a poet
If Noelle Kocot (8,290 results) is a poet, I don't want to be a poet
If Laynie Browne (8,390 results) is a poet, I don't want to be a poet
If Laura Mullen (8,830 results) is a poet, I don't want to be a poet
If Rusty Morrison (8,840 results) is a poet, I don't want to be a poet
If Jennifer Moxley (8,940 results) is a poet, I don't want to be a poet
If Stephen Rodefer (9,130 results) is a poet, I don't want to be a poet
If Joseph Ceravolo (9,150 results) is a poet, I don't want to be a poet
If Victor Hernández Cruz (9,380 results) is a poet, I don't want to be a poet
If Bin Ramke (9,530 results) is a poet, I don't want to be a poet

If Gustaf Sobin (9,720 results) is a poet, I don't want to be a poet

If Sharon Mesmer (10,100 results) is a poet, I don't want to be a poet

If Myung Mi Kim (10,100 results) is a poet, I don't want to be a poet

If Kenward Elmslie (10,600 results) is a poet, I don't want to be a poet

If Charles North (10,700 results) is a poet, I don't want to be a poet

If Maureen Owen (10,900 results) is a poet, I don't want to be a poet

If Julie Carr (11,000 results) is a poet, I don't want to be a poet

If G.C. Waldrep (11,100 results) is a poet, I don't want to be a poet

If Gary Sullivan (11,300 results) is a poet, I don't want to be a poet

If Paul Violi (11,300 results) is a poet, I don't want to be a poet

If Kathleen Fraser (12,100 results) is a poet, I don't want to be a poet

If Noah Eli Gordon (12,200 results) is a poet, I don't want to be a poet

If Carla Harryman (12,400 results) is a poet, I don't want to be a poet

If Joan Retallack (12,900 results) is a poet, I don't want to be a poet

If Joshua Marie Wilkinson (13,000 results) is a poet, I don't want to be a poet

If Larry Eigner (13,100 results) is a poet, I don't want to be a poet

If Elizabeth Willis (13,500 results) is a poet, I don't want to be a poet

If Hannah Weiner (13,700 results) is a poet, I don't want to be a poet

If Donald Revell (14,300 results) is a poet, I don't want to be a poet

If Tan Lin (14,400 results) is a poet, I don't want to be a poet

If Edwin Torres (14,400 results) is a poet, I don't want to be a poet

If Mei-mei Berssenbrugge (15,000 results) is a poet, I don't want to be a poet

If Maxine Chernoff (15,000 results) is a poet, I don't want to be a poet

If John Wieners (15,100 results) is a poet, I don't want to be a poet

If Craig Dworkin (15,400 results) is a poet, I don't want to be a poet

If Christian Bök (15,700 results) is a poet, I don't want to be a poet

If Eleni Sikélianòs (15,800 results) is a poet, I don't want to be a poet

If Ronald Johnson (16,400 results) is a poet, I don't want to be a poet

If Robert Grenier (16,500 results) is a poet, I don't want to be a poet

If Miguel Algarín (16,700 results) is a poet, I don't want to be a poet

If Ann Lauterbach (16,900 results) is a poet, I don't want to be a poet

If Mark McMorris (17,000 results) is a poet, I don't want to be a poet

If Jessica Hagedorn (17,400 results) is a poet, I don't want to be a poet

If K. Silem Mohammad (17,900 results) is a poet, I don't want to be a poet

If Keith Waldrop (18,000 results) is a poet, I don't want to be a poet

If Brian Kim Stefans (18,000 results) is a poet, I don't want to be a poet

If Catherine Wagner (18,500 results) is a poet, I don't want to be a poet

If CA Conrad (18,700 results) is a poet, I don't want to be a poet
If Nada Gordon (19,000 results) is a poet, I don't want to be a poet
If Amy Gerstler (19,100 results) is a poet, I don't want to be a poet
If Gillian Conoley (19,400 results) is a poet, I don't want to be a poet
If Bill Berkson (19,800 results) is a poet, I don't want to be a poet
If Michael Davidson (19,900 results) is a poet, I don't want to be a poet
If Will Alexander (20,000 results) is a poet, I don't want to be a poet
If Art Lange (20,200 results) is a poet, I don't want to be a poet
If Wang Ping (20,500 results) is a poet, I don't want to be a poet
If Russell Edson (20,700 results) is a poet, I don't want to be a poet
If Susan Wheeler (20,800 results) is a poet, I don't want to be a poet
If Lorenzo Thomas (20,800 results) is a poet, I don't want to be a poet
If Vanessa Place (21,600 results) is a poet, I don't want to be a poet
If Elaine Equi (21,700 results) is a poet, I don't want to be a poet
If Clarence Major (21,800 results) is a poet, I don't want to be a poet
If Barrett Watten (21,900 results) is a poet, I don't want to be a poet
If Ed Dorn (21,800 results) is a poet, I don't want to be a poet
If Andrew Joron (22,000 results) is a poet, I don't want to be a poet
If August Kleinzahler (22,100 results) is a poet, I don't want to be a poet
If John Godfrey (22,700 results) is a poet, I don't want to be a poet
If Cole Swensen (23,400 results) is a poet, I don't want to be a poet
If Paul Blackburn (23,500 results) is a poet, I don't want to be a poet
If Jayne Cortez (23,600 results) is a poet, I don't want to be a poet
If Claudia Rankine (23,800 results) is a poet, I don't want to be a poet
If Paul Hoover (24,000 results) is a poet, I don't want to be a poet
If Elizabeth Robinson (24,700 results) is a poet, I don't want to be a poet
If Norma Cole (24,700 results) is a poet, I don't want to be a poet
If Bob Perelman (25,300 results) is a poet, I don't want to be a poet
If Anselm Hollo (25,400 results) is a poet, I don't want to be a poet
If Lisa Jarnot (25,800 results) is a poet, I don't want to be a poet
If David Antin (26,200 results) is a poet, I don't want to be a poet
If Diane Wakoski (26,500 results) is a poet, I don't want to be a poet
If Hilda Morley (27,200 results) is a poet, I don't want to be a poet
If John Yau (27,300 results) is a poet, I don't want to be a poet
If Clark Coolidge (27,500 results) is a poet, I don't want to be a poet
If Linh Dinh (27,700 results) is a poet, I don't want to be a poet
If Bernadette Mayer (27,900 results) is a poet, I don't want to be a poet

If Harryette Mullen (28,000 results) is a poet, I don't want to be a poet
If Jackson Mac Low (28,200 results) is a poet, I don't want to be a poet
If Wanda Coleman (28,200 results) is a poet, I don't want to be a poet
If Bruce Andrews (28,300 results) is a poet, I don't want to be a poet
If David Shapiro (28,800 results) is a poet, I don't want to be a poet
If Barbara Guest (28,800) results) is a poet, I don't want to be a poet
If Fanny Howe (29,400 results) is a poet, I don't want to be a poet
If Peter Gizzi (28,900 results) is a poet, I don't want to be a poet
If Ben Lerner (30,000 results) is a poet, I don't want to be a poet
If Jimmy Santiago Baca (31,800 results) is a poet, I don't want to be a poet
If Rosmarie Waldrop (31,900 results) is a poet, I don't want to be a poet
If John Giorno (32,500 results) is a poet, I don't want to be a poet
If George Evans (32,500 results) is a poet, I don't want to be a poet
If Laura Moriarty (34,100 results) is a poet, I don't want to be a poet
If Steve McCaffery (35,500 results) is a poet, I don't want to be a poet
If Nathaniel Mackey (36,900 results) is a poet, I don't want to be a poet
If Dennis Cooper (40,100 results) is a poet, I don't want to be a poet
If James Schuyler (40,300 results) is a poet, I don't want to be a poet
If C.D. Wright (40,300 results) is a poet, I don't want to be a poet
If Alice Notley (42,300 results) is a poet, I don't want to be a poet
If Diane di Prima (42,600 results) is a poet, I don't want to be a poet
If Kenneth Goldsmith (42,600 results) is a poet, I don't want to be a poet
If Ed Sanders (43,400 results) is a poet, I don't want to be a poet
If Leslie Scalapino (45,100 results) is a poet, I don't want to be a poet
If Ron Padgett (45,700 results) is a poet, I don't want to be a poet
If Clayton Eshleman (46,200 results) is a poet, I don't want to be a poet
If Robert Kelly (46,500 results) is a poet, I don't want to be a poet
If Lyn Hejinian (48,800 results) is a poet, I don't want to be a poet
If Ted Berrigan (50,300 results) is a poet, I don't want to be a poet
If Eileen Myles (51,200 results) is a poet, I don't want to be a poet
If Tao Lin (51,300 results) is a poet, I don't want to be a poet
If Andrei Codrescu (56,200 results) is a poet, I don't want to be a poet
If Philip Whalen (57,400 results) is a poet, I don't want to be a poet
If Susan Howe (58,000 results) is a poet, I don't want to be a poet
If Jorie Graham (58,600 results) is a poet, I don't want to be a poet
If James Laughlin (58,100 results) is a poet, I don't want to be a poet
If Michael McClure (62,300 results) is a poet, I don't want to be a poet

If Michael Palmer (65,000 results) is a poet, I don't want to be a poet
If Jim Carroll (65,400 results) is a poet, I don't want to be a poet
If Jack Spicer (68,400 results) is a poet, I don't want to be a poet
If Natasha Trethewey (70,800 results) is a poet, I don't want to be a poet
If Tom Clark (75,300 results) is a poet, I don't want to be a poet
If Anne Waldman (77,300 results) is a poet, I don't want to be a poet
If Ron Silliman (78,700 results) is a poet, I don't want to be a poet
If Kenneth Koch (79,500 results) is a poet, I don't want to be a poet
If Bill Corbett (82,600 results) is a poet, I don't want to be a poet
If Jerome Rothenberg (84,000 results) is a poet, I don't want to be a poet
If Kay Ryan (87,100 results) is a poet, I don't want to be a poet
If Mark Doty (98,400 results) is a poet, I don't want to be a poet
If Charles Wright (99,500 results) is a poet, I don't want to be a poet
If Gregory Corso (101,000 results) is a poet, I don't want to be a poet
If David Lehman (112,000 results) is a poet, I don't want to be a poet
If Charles Olson (116,000 results) is a poet, I don't want to be a poet
If Robert Duncan (122,000 results) is a poet, I don't want to be a poet
If Charles Bernstein (129,000 results) is a poet, I don't want to be a poet
If Robert Pinsky (141,000 results) is a poet, I don't want to be a poet
If Denise Levertov (143,000 results) is a poet, I don't want to be a poet
If Robert Creeley (147,000 results) is a poet, I don't want to be a poet
If Rita Dove (148,000 results) is a poet, I don't want to be a poet
If Charles Simic (149,000 results) is a poet, I don't want to be a poet
If W.S. Merwin (155,000 results) is a poet, I don't want to be a poet
If Lawrence Ferlinghetti (158,000 results) is a poet, I don't want to be a poet
If Audre Lorde (166,000 results) is a poet, I don't want to be a poet
If Robert Hass (169,000 results) is a poet, I don't want to be a poet
If Gary Snyder (216,000 results) is a poet, I don't want to be a poet
If Amiri Baraka (224,000 results) is a poet, I don't want to be a poet
If Rae Armantrout (224,000 results) is a poet, I don't want to be a poet
If John Ashbery (243,000 results) is a poet, I don't want to be a poet
If Mary Oliver (310,000 results) is a poet, I don't want to be a poet
If Adrienne Rich (323,000 results) is a poet, I don't want to be a poet
If Anne Sexton (339,000 results) is a poet, I don't want to be a poet
If Catullus (355,000 results) is a poet, I don't want to be a poet
If Robert Lowell (363,000 results) is a poet, I don't want to be a poet
If Frank O'Hara (361,000 results) is a poet, I don't want to be a poet

If John Cage (375,000 results) is a poet, I don't want to be a poet
If Billy Collins (410,000 results) is a poet, I don't want to be a poet
If Dante Alighieri (417,000) is a poet, I don't want to be a poet
If Jack Kerouac (497,000 results) is a poet, I don't want to be a poet
If Allen Ginsberg (521,000 results) is a poet, I don't want to be a poet
If Charles Bukowski (523,000 results) is a poet, I don't want to be a poet
If William Wordsworth (526,000 results) is a poet, I don't want to be a poet
If Sylvia Plath (547,000 results) is a poet, I don't want to be a poet
If Maya Angelou (722,000 results) is a poet, I don't want to be a poet
If Walt Whitman (732,000 results) is a poet, I don't want to be a poet
If Langston Hughes (754,000 results) is a poet, I don't want to be a poet
If Robert Frost (812,000 results) is a poet, I don't want to be a poet
If Emily Dickinson (980,000 results) is a poet, I don't want to be a poet
If Homer (4,160,000) is a poet, I don't want to be a poet
If Socrates (7,700,000 results) is a poet, I'll consider it
If Andy Warhol (16,300,000 results) is a poet, I want to be a poet

Breakfast at Tiffany's; Dinner at Goldsmith's

On Daniel's Canon and Kenneth's Memes

Kenneth Goldsmith. Photo by
Marisol Rodríguez.

In Summer 2014, Professor Daniel Tiffany proposed a canon in the Boston Review *that dealt with poets doing the sort of work discussed in my* Notes. *In this article for* Lemon Hound, *I refute his formation, valorize my own, and also take a look at the very popular memes of Kenneth Goldsmith (as both KG and DT share a Straight White Male universalist utopianism that turns the radical cut into a vanilla lick).*

Fittingly, given the issues raised (encapsulation, memes, reduction, reification etc.) you can think of this piece as the ready-to-wear version of Notes. *It's followed by a postscript that uses the same frame of glancing to critique Brian Reed then briefly outlines an alternative methodology.*

In his article "Cheap Signaling," Tiffany argues that there is something new amongst a freshly

grouped constellation of poets. That something new (to be brief: culture jamming) is not far from what I have written about here. In Tiffany's particular constellation, we seem to see poets working steadily in the traditions of Flarf and the Gurlesque, traditions that involve appropriating language from the Internet, pop culture, ethnic culture, often with a somewhat comedic intent. Additionally, he has thrown Anne Boyer into the mix, probably to give a radical feminist Marxist street-cred to his argument, and in spite of the fact that her work with its serious critical tone (that lacks the ironic parodic linguistic 'play' of many of the poets he mentions) just doesn't fit what he is proposing. Obvious problems concerning his overlooking of racial and gender appropriation are crucial to discuss, but in the end, Tiffany claims these problems are irrelevant because his piece is about, point-blank, class. But though class is mentioned, class inequality is not looked at (anthropologically or economically or at all) but skipped over, as Tiffany flies straight to the utopian premise that the poets listed exceed class brackets and identity configurations. No longer a black poet or a white poet playing particular games with particular linguistic frames that cause micro-level subversions, his new constellation of poets, by his assumptions, are universally rupturing the system of class and forming a large meta-class of urbane bohemians who have a relatable inclusive authenticity, despite being counter-cultural and making fun of authenticity. Moreover, they have a direct relationship to pop and mainstream culture, and do not merely stand opposed to it in the stark Adornoian tradition.

Is this bunch of self-consciously complicit yet still leftist bohemians somehow also a resurrectionary Marxist faction important to the avant-garde canon? Tiffany answers resolutely yes, and does so without recourse to any socio-economic or anthropologic-historical argumentation or proof. Not that I am asking for a demonstration that the class system has been altered materially by these artists, but even just demonstrating how any person's ideals about the class system had been altered by these artists would be useful. As the argument is framed, it appears not that these artists have altered Tiffany's ideas about class, but rather that these artists were useful to illustrate ideas about class that he already held. Though he avoids the topic of Con-

ceptual poetry, this sort of utopianism (a bohemia apart from the class system) is absolutely consonant with Kenneth Goldsmith's recent memes that disparage Adorno, celebrate Twitter as a form of modernist art, and argue with a kind of Napster-Mac-Utopianism that copyright is dead. However he is never able to sustain a claim that these things alter the fundamental economic system of capitalism or even alter the hierarchical formations of art canonization, even if they make both appear to be more 'inclusive,' radical, and hip.

This shift against Adornoesque tendencies to control not just modernism but also postmodernism, has been signaled as well in art world discourse by the shift from the core set of *October* criticism with its postmodern 'masters' (particularly the writings of Hal Foster, Rosalind Krauss, Benjamin Buchloh) to the looser, queerer, micro-masters proposed by *Grey Room* and recent issues of *Artforum* (particularly in the writings of Claire Bishop, Ed Halter, David Joselit). Here, by throwing out the king (Adorno, Foster, Brakhage, etc.) an attempt to yield a more fluid sense of the contemporary is given; yet nonetheless, as happens when kings are dispatched, the superego becomes more secretively coercive, power structures seem more neutral and less contestable. And thus there is an unconscious repetition of Adorno's hierarchies even as they are attempted to be undone. Indeed, this is the case with articles like Tiffany's and in fact, the whole *Grey Room*, queer theory, micro-master enterprise. (Therefore it becomes harder to question the judgments that raise an artist like Ryan Trecartin into a superstar because it seems that this is beneficial to 'us' as a community, not just art patriarchs and academics: or at least, this is the story as it is told by Christopher Glazek in *n + 1*.) Goldsmith's recent memes and Tiffany's article (as well as the work of Joselit, for example) share a cloying desperation for empathy and empathic communities, as well as for adulation and shared canon values, all the while seemingly debunking the notions of such clean-cut canons as high art would premise. In Goldsmith's case the refusal to be entertained by emotional tweets is all the more ironic given how pathos-ridden his memes are.

Indeed, Goldsmith's work brings us face to face with the problematics of doing universalizing PR for microcultural formations. There's a kind of horror then to his persona, even a sort of terror, for those who have fought to keep the idealized hermetic circle of experimental art sacred. And yet what Goldsmith is doing is hardly unique. Besides being enacted by the SparkNotes and textbook industry, professors and artists, who should allegedly be better equipped to write, think, and teach in less streamlined ways, have tended to opt for the sales pitch. In part because the customer comes first, and the customer is in this case the college student, a teen-consumer who wants to do as little work and thinking as possible but certainly wants a *Hot Topic* T-shirt of Adorno or Perloff. This is not to say that the wearing of a *Hot Topic* T-shirt denies that there is a 'thinkership' at play here, a group of thinkers who are thinking through the irony of their inability to transgress in palpable ways.

However, it does not take a cynical historian to note that this particular brand of irony is too much old-news to be described as inventive. It is not particularly inventive to write in *Artforum* or *Mousse* that this sort of irony is not Marxist enough, as if there is some better more authentic form of Marxism or that the hermetic art is somehow more authentic or sincere or better than post-80s art (a point that even Goldsmith traffics in). If one takes this position in such a blasé way, especially within academic and art-world discourses, it merely reifies that work, and canonizes it by virtue of it having a comparative moral high-ground, as if that is what is important about the art.

All I am saying here is not that fourth-generation conceptual, ironic, institutional critique and culture jamming is immoral and ought not to be made or discussed (after all this is the sort of art I make too) but merely that it is not inventive. However, Goldsmith is able to traffic his work as new-news because what he does has not occurred in poetry per se, though it had in art, for the reason that it had been useless to make jokes about the complicity of poetry with capitalism when poetry had been so entirely uncommodified for so long. Goldsmith's magic act was to make poetry seem like an art/fashion object that could be considered a commodity and as soon as he did this,

he also simultaneously pointed to the irony of this fact. However, this joke is hard for others to maintain since the poetry book, even Goldsmith's is still not a valuable commodity on par with a Warhol painting. Thus, there is a sublime irony in a Warhol painting that will always fall flat, comparatively, when viewing a Goldsmith book. For one thing, a main enjoyable feature of Warhol's works is owed to his paintings selling for millions, despite being appropriations. Goldsmith's work is not selling for millions, whatever his dandy posturing might indicate, and therefore the joke does not translate.

Still, there is something to Goldsmith that can't be said of Tiffany, which is the ambivalence in his memes points to an underlying sadness: that what he is saying is beyond even his own belief systems. It is clear in many ways that Goldsmith is trying to keep up with the kids (or at least the Kardashians), the desperation is there as a kind of humor, call it the humor of the hipster. While it is a generic, even sophomoric humor, only acting as inventive genius, nonetheless it demonstrates more wit and intelligence than the humorless prose of Tiffany. Though, one must note that plenty of academics, such as Jeffery Nealon, who attempt to use humorless prose to defend Goldsmith as if he were doing the same thing as they are, try to turn counterculture and subculture and the quotidian and the queer into a teachable 101 English course that can also be deemed Marxist and transgressive, despite being entirely catered to middle-class students. These professors, like Tiffany and Nealon, reduce the ambivalent complexity of works that trade in the culture industry so that they seem unilaterally 'negative' in the sense of holding up a critical mirror, and this, of course, to our shared Leftist-Marxist values is meant to be positive. And yet what might be most interesting and dangerous about these works is that they really just wanna have fun, that is they might not be doing anything Marxist whatsoever, they might just be participating in the mass hysteria, and enjoying it.

The second mistake that professors like Tiffany make is that they attempt to domesticate the nomad, and treat works that explicitly avoid partaking in the culture industry or the industry of dogmatic interpretations (the academy) as if they did (Tiffany does this with Anne

Boyer's work) or should. Tiffany hopes to argue that the interruptive impediments to communicative seamlessness marked by poetry ought to be viewed as the very enabling conditions for a political-ethical community. Though what he ought to say is: interruptive, rambunctious, difficult poetry forms the enabling conditions for his own seamless, safe, academic prose.

Tiffany writes in *Infidel Poetics*, "Obscurity, rather than being the principal impediment to poetry's social relevance, would provide the key to models of community derived specifically from the nature of lyric expression." His punchline is not unlike the desire to make a meme of the hermetic: Solipsism is socially connecting! Secrecy is expressive! Hostile politically indifferent poetry is polite and universal and leftist-Marxist! The impossibility of communication is the grounds on which communication is built! Disturbingly tricky riddles can be very catchy!

In my *Notes*, I ask a different question: Is not the creation of a single category of erudite bohemian—merging the learned academic with the street rapper through a common language of uncommon speech, of slang and remix—is this not merely the fantasy of a middle class, each with their Macs and each with their artistic hobbies? Exceeding class, race, and gender, while not actually doing anything to rupture the distribution of wealth? Even thinkers as astute as Žižek have fallen into the trap of attempting to create this unity—to move beyond identity politics and to deliver us a counterhegemonic kernel of transgressiveness, a wounding punctum, not unlike queerness that would unite high and low, rich and poor, through nothing more and nothing less than a middle class oasis. This connects thinkers as unlikely as Žižek to the more routine Affect Studies tactic, of celebrating negative affects that speak to middle class students into positive radicalized badges-of-honor. Such is the routine used, for example, when Sianne Ngai admires Bruce Andrews: the curse word and the disgust it implies can become an identifiable place for empathetic unified transgression.

What the academy, from Žižek to Ngai to Tiffany has been able to do, is create a queer-Marxist post-class class of bohemians connected at

the hip to the World Wide Proletariat-Queer. At most, the art historical import of this strategy has allowed for an extensive cataloguing of the transgressive hopes and negative feelings of a principally middle class group of recognized artists. The need to immediately rush to the ethical-moral defense of art is the problem here. It means skipping over the search for proof and for reality. One needs to slow down and look either anthropologically or socioeconomically at these problems or else, at least, bite the bullet and examine the art for merely its own aesthetic and formal properties without attempting to redeem it or make everybody love it. Or if one has not the skill to do any of those things, then at least be a little bit more critically acute. To start, here's a very basic entry-level question Tiffany and Goldsmith might ask, to open the door to critical self-reflexiveness: do not our doors remain just as locked as they were before Napster and Ubu and Queer Theory and hip-hop? Or at least ask, whom does transgression serve, rather than simply saying ad nauseum "this is transgressive." Then one can start to investigate the phenomenological distinctions in how the work serves, how intelligent or witty it is, how provocative, etc. Of course, this means making specific judgments and risking the posture of the fanciful elitist. But this risk must now be made, as the attempt to bill artworks as *a priori* novel and unique, based on a set of ethical egalitarian pretenses, is a tactic that has finally run its course.

Postscript

In 2013, the first full-length academic study of Flarf and conceptual poetry, Brian Reed's *Nobody's Business: 21st-Century Avant-Garde Poetry* was published. Reed makes an increasingly common claim that a fondness for ineptitude, error, and queerness are creating a new sublime. Unfortunately, this requires defaulting on the idea that the avant-garde interrupts a corporate seamless lyrical culture like mainstream poetry. Then again, most Internet users and TV watchers (also corporations like Apple) expect and take delight in "the queer art of failure." As many (notably Michael Robbins) have been quick to note, Language poetry's tactics are not consistently counter-traditional since there really is no mainstream American tradition.

I don't wish to deny the imaginary import of pataphysical and dialectical resistance to perceived mainstream norms, even though such norms may not be as "external" to the transgressive group as imagined. Of course, there are ways to investigate what's mainstream and what's not such as looking at poet laureates and awards, book sales, twitter followers, citations in the critical literature, etc. There is always a sociological, poethical, and aesthetic importance to the claims of transgression, however unsubstantiated with concrete evidence, and the inventions of various "reals" at various points in time. And anything that attempts to critique all transgression and counter-tradition is itself inventing its own conception of the real (the real-as-ideological-critique). Aesthetically inventive artworks are mostly noticed retrospectively, once their power has dulled. The mark that we are continually trying to hit would be that of genius, an all too quickly disposed (or else too quickly overused) nomination that refers to the individual artist as a unique monad, whose work cannot be reduced to a set of prevailing relationally contingent moral factors or even to aesthetic fancies.

Reed concedes that new experimental work is not necessarily art for the ages, nor does it necessarily have a Marxist violence. He argues that such work has "vigilant relationships between power, knowledge, and language" and an awareness of its contingent futurity, as if on the verge of being wiped out by another impending radicalism. For Reed, that makes such work no less—interesting? important? worthy of the canon? (Not quite sure what the rub is here.) This is an avant-garde of openness, multiplicity, flexibility; a reversal of Adorno in its kind of democratic neutrality regarding materials and its anti-militancy. *Hyperallergic* instead of *Artforum*; PS1 instead of MOMA.

Countercultural objects ought not be valorized for simply having a prescient understanding of the present/future. The latest iPhone has a vigilant relationship to power, knowledge, and language: in fact it's hyper-vigilant—a visionary collaging of power, knowledge, and language—moreover with a built-in obsolescence, so its makers are surely aware of its own contingent futurity. You could complain that the iPhone is an elite device for the middle class, but it's not nearly as

expensive as most of the important objects that circulate in the art galleries (a zone of production that it is supposed to be wonderful that poetry is melting into). Moreover, the iPhone can be comparable in price to some hardcover academic books, to say nothing of college courses themselves.

The standard academic narrative of transgression and normativity certainly reflects social change—nonetheless the scholar can use critical shrewdness to disidentify with social trends and even strain for objectivity, though one risks being stigmatized as amoral or patriarchal (this is absurd given how scientific and clinical the banal operation of academic 'transgression' hunting is: it is cloaked in a jargon and quarterly officiality that is deadening, but attempts to rebuke this are said to be traditionalist and antisubjective).

One trouble is that art history and English are so contained that their scholars are bound to fall all too hard for would-be novelties. The creation of the category "new media," with its obligatory MIT-press books on Internet Art, goes hand in hand with pathetic attempts to avoid the sociological wasteland of the Internet and the global scale of MFA programs churning out homogenous approaches to things like queerness and remixing and "deschooling." Instead: one or two artists are looked at, usually for their ability to somehow critique or reflexively display the wasteland (but this is what everyone in the wasteland does). These artists are removed from the wasteland of their contemporaries, and compared instead to the most conservative art works, so that they seem transgressive by association. Or else one or two particular examples of 'waste material,' like Minaj or Gaga or maybe even a plebian (if they were involved in a court case or otherwise viral attention) are incorporated into the academy as 'tokens' and then defended through dissertations/apologias footnoting the masters (Foucault or Butler and the like). The general disregarding of mass culture and street culture (and soon Internet culture) is then rectified by the recuperative scholarship on one or two 'forgotten' marginals, usually at least forty years later.

This doesn't lead me to take a normcore-deadpan-postmodern approach that insists transgression will always fail, and that one must wallow in normality or banality—hedonistically laying claim to the vapid variation on the death drive called hipster nihilism. Normcore and nihilism are ideological fictions (not to mention brand names), which is not to say that they don't have very real meanings to their adherents. One can study the particularities of various ideological frames (inside and out) without falling for their bait, which doesn't mean viewing art as only art-for-art's-sake or anti-redemptive negative queerness or anti-art for the sake of a new sublime.

I want an approach to art that does not pit the untraversed fantasy of idiots against the heroically traversed works of genius. Aesthetic differentiations are great, but they are always already particular to your corpus, and it is only in flexing your own particular superego that you can make that supercilious, crucial distinction between the bird of genius and the common sparrow. You won't always land on the raven, but it's worth a shot (as long as the shooter has been practicing their aim rather than snuggling up to their nearest benchmarker of aesthetic comfort).

The most readily accessible transgressive kernel of the real or the most nihilistic voided reality must not be seen as the end-all be-all. Aim the gun a little higher.

I agree with Reed that Conceptual poetry can really infuriate those trying to make "hybrid poetries" that use Language poetry and earlier avant-garde tactics to produce vanilla boring art. In the poetry context, Conceptual poetry may sometimes 'transgress' a dull hybrid poetics. Still, Conceptual poetry achieves its originality by reverting to the most banally overused tactics of the visual arts. So it's half a dozen Transgressive points and six Banal points.

Goodness and novelty depend on which cultural frame you use (which academic department one is in or which decade one was born in). But just saying this as a disclaimer isn't enough. The frames that you/ they/we are using must be tortured with a scalpel. Reed, for example,

starts by suggesting a generational frame shift caused him to write his book in the first place; he had preferred to write about Susan Howe and C.D. Wright into the early 2000s but then realized his students were feeling more affectively charged by Flarf and Conceptual poetry for the very reasons he despised it, so he started to give it a shot. That happens! But what does it mean that this happens?

The fact that young people feel affectively connected to something is not a good enough reason to claim it has political or aesthetic merit, but only that it might have that merit to a certain group's Imaginary at a particular time. It is certainly one good way to find what's "new" (or hip or cool, for a specific group of American millennials). To deliriously praise what is 'new' is symptomatic of a culture in which academic precision has been replaced by slapdash appeals to fashion and trends; as professors must cater to their students' tastes when creating their syllabi and writing their books. This is why the queer canon has become overwhelmingly oriented towards making life nice for middle class college-educated Western students. It's their happy meal, as opposed to their 'vegetables.' After all, a lot of Judith Butler's queer theory comes out of finding ways to adapt French theory to *Rocky Horror Picture Show* shadow players (undergrads who reenact the cult film while it screens at midnight). *Dammit Janet—my student feedback report just came back—Phew, it's a 10/10, as always.*

Again, what is radical at a high school in the Midwest or in Russia is not necessarily radical in New York City nightlife, something the urban QueerArtIlluminati can't admit: leading to a kind of gay left orthodoxy (or in the academic variety: the three-hundredth dissertation to 'find' subversiveness or queerness in a text that has been canonized for centuries).

It is the artist's job to intuitively sense what it is the critic's job to parse out: not only the relative importance of different radicalisms but also their value in the final instance. This does not mean to sharply critique all left radicalism, only to fall back on a right-wing restoration of old values. Think: Bruce Bower taking a smug but shrewd stance against identity politics but then defaulting on a new formalism and a

sanitary gay domesticity, or Alan Kors sharply critiquing the kangaroo courts that spring up due to issues of political correctness on college campus but then defaulting on a banal libertarianism, with old-fashioned 'good values' that stink of patriarchy.

This is hard: as we are all hampered by a commitment to that group (classical or romantic, traditional or revolutionary) which can protect us from the black sheep. Why forge your critiques and your visions *vehemently* outside the pack of protection? Why do something so impractical and superfluous? Why risk solo confrontation with the black sheep ... or worse, becoming him (and getting terrorized by the mob)? Nonetheless, the rare artist does this intuitively (if only occasionally) and the rare critic strives to notice. Everyone else is, at best, *fine*: fine artists, fine politicians, fine designers, fine athletes, fine entertainers, fine humorists, and fine curators.

The Golden Mean

On Alt Lit, New Sincerity, the Ashbery School, and Dorothea Lasky

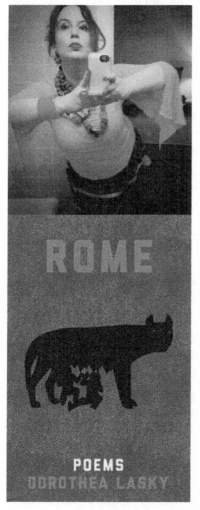

Dorothea Lasky is the ello of poetry. She gives us poems that are cute, zany, and interesting on a clean ad-free platform that is friendly, complex, and interpersonally sensitive. She is poetry's great white hope, offering up a golden mean between radical and formal, romantic, and classical. In this way she is an heir to the throne that W.H. Auden left to John Ashbery, who is a central figure in her life. Indeed, Lasky is, along with Timothy Donnelly and Adam Fitzgerald, a core faculty member of the John Ashbery Home School, a poetry camp that welcomes younger writers into the lineage of one of the 20th-century's greatest poetry icons. And Lasky is their star.

Rome (Liveright/Norton, 2014) is Lasky's first book from a major imprint, and it shows that in 2014 there can still be a well-crafted

poetics, celebrated by mainstream critics and out-of-touch academics, that nonetheless doesn't abandon a commitment to the experimental, innovative, and peculiar. Ashbery has a stellar track record in appealing to most parts of the poetry spectrum: the experimental 70s Language poets adored him but so did mainstream lyric poets, and leading literary critics from Helen Vendler to Harold Bloom to Marjorie Perloff all regard him highly. Additionally, Ashbery rarely offended; though he is a successful (white) patriarch, he is also a sweet soul, and a sort of make-believe closeted homosexual, who never played the *poete maudit* and who eschewed identity politics. Beyond that, Ashbery's poems are richly affective and rarely dry, despite being philosophically pristine.

Rome is a major achievement in which Lasky shows that she can be sincere and ironic, confessional and ambiguous, without having to be trashy or pornographic like much of the poetry trafficked under the banner Alt Lit (where internet art meets neurotic sexual confession). She pays attention to the lineage of formally experimental poetries and deconstructive philosophies without being thrown into a world where language is fully arbitrary and authorship merely a brand. Lasky's is a world where the poem matters and not just the wink of the author (as in the conceptual poetry of the early 2000's exemplified by Kenneth Goldsmith) and indeed where the author matters, not just the semiotic world of the text (as in the Language poetry of the 1970s). Moreover, in Lasky's work, the reader matters and not just the social network or media platform (as in much contemporary post-conceptual poetry and Net Art).

Lasky is the proper awakener of what Yeats hoped would arrive as a second coming; that is, she offers the remedy to the chaos of our cultural wastelands without turning to the Anglican church. She is the sincere artist who rebels against the postmodernism that David Foster Wallace predicted would come in his 1993 essay "E Unibus Pluram Television and U.S. Fiction." Yet, this rebellion, like all attempts at rendering New Sincerity, rarely abandons the circuitry of irony and didacticism characteristic of postmodernism, nor is it a visionary retreat into Blakean system building. Rather, Lasky, like main New

Sincerity artists (Joanna Newsome is an apt example), has pushed her own affective brilliance through indie and hipster culture, with a whine and a whimper rather than a bang. The zany, queer, affective, and cute have not replaced and surpassed the postmodern, ironic, and flat or even replaced the sublime, beautiful, and symmetrical but rather, at their best, have joined them all together into a hybrid that remains experimental and fun and new, while at the same time moral and humane.

Striking a happy medium is a conceit that often invites ahistorical excitement: this is the first time irony and sincerity, flatness and roundness, experimentality and formalism, intellect and affect have come together! The seemingly endless attempts to define a newly minted happy medium are often most striking for their scent of déjà vu. Just consider, of late, Daniel Tiffany writing in *Boston Review* that poets have found a way to reconcile Marxist class awareness with complicit pop culture adoration; or Kareem Estefan writing (in *Art in America*) that Ryan Trecartin has mixed conceptual poetry tactics with affect in an unprecedented way; or Seth Abramson (in the *Huffington Post*) celebrating "metamodernism" as a way to bring New Sincerity to poetry and return to an affective, transcendent, populist, DIY style, as of all that was lost with postmodernism's preoccupation with the arbitrary. All this ahistorical clickbait pretends as if all of 70s and 80s poetry was empty postmodernism. This is understandable since this is how Fredric Jameson dismissed Language poetry, in his infamous critique of postmodernism, as flat, shallow, and vapid. But this is to willfully ignore postmodernist works that include vivid, visionary ecstasies both in theory and in poetry (for example, the poststructuralism of Deleuze, the poetry of Steve McCaffery).

Even the artworld and pop cultural manifestations of postmodernism like Madonna and Warhol are clearly invested with complexity in regard to issues of irony versus sincerity. Sure, they weren't sickly sweet like the 90s music known as New Sincerity (Connor Oberst or Eliot Smith) but it would be hard to provide evidence that one or the other is, by default, more ethical or aesthetical: plenty of New Sincerity indie work is totally mainstream and boring (think of Daniel

Johnston), so simply saying that emphasizing emotionality has some sort of connection to radical poethics is astoundingly counterfactual. To paint all of postmodernism as affectless is to naively buy into the sweet lies of its artworld brand name.

However, the trick of 'forgetting' this *other* part of postmodernism is necessary if today's discovery of the 'real' is to be new. Even conceptual poetry, so out-and-out dogmatic in its claim to be *Against Expression* is hardly uncreative or anti-affective, but rather revels in a kind of zombie post-traumatic flat affect. Abramson even agrees with his antichrist Goldsmith on most issues: both endorse Steve Roggenbuck, Net Art/Alt Lit sensation whose sentimentality Goldsmith compares favorably to Whitman. Moreover, both claim to be returning to modernism and escaping postmodernism but basically put forward work that is strikingly similar to postmodern works.

The one person Abramson might want to take issue with is Vanessa Place, who says point blank that poetry is dead, by which she means it is wholly banal and uninteresting. The hybrid mixing of left and right, mainstream and fringe, the striking of a golden medium is ubiquitous: from books that sell in Urban Outfitters to the ones selling in Printed Matter to the ones selling in small poetry shops. The hybrid dominates. Everyone is experimental but crossing over. This all being symptomatic of the statement Goldsmith has cheekily offered: "Poetry will be made by all," which means it is also dead, as a matter of interest to the critic. Rather, slapdash networking tactics, the rule of the neophilic fashionable and cool seem to dictate how Goldsmith will orient and rank this world where poetry and experimentality is ubiquitous. One has yet to see a rigorous explanation of his tastes or a truly historical account (*Against Expression*, his anthology, being the exception, and this in part due to co-editor Craig Dworkin). Even still, Goldsmith is heroic here. As he is one of the few in the academy or public eye who is even attempting to deal with this work: Marie Calloway, Trisha Low and even Drrty Pharms are deeply interesting, and pose long-term challenges to what we expect from good literature, but most of the rest of the "made by all" all-stars are overrated Tao Lin acolytes mindlessly riding a wave like Beatlemania or any other

youth culture phenomenon. The trouble is Goldsmith does not seem to have a good way to tell the difference and it comes off as arbitrary, mechanical, trend-sniffing, which is fine, as long as you think you need an older figurehead to tell the rest of the adults who the kids like these days.

But what Goldsmith and even Abramson find in Roggenbuck is not what I find in Lasky. The worldwide hybrid that creates a new American dream where everyone can be queer, marginal, difficult, avant-garde but also central, cool, mainstream is too easy to make for an especially good poet. Roggenbuck offers a nice foil for difficult poetry to ease into the youth-cultural pop-cultural spirit but this also means a detachment from the writerly, in favor of the performative. Lasky and her Ashbery school offer a solution: poetry will be made by *some!* Those with "good ears." Then we can keep poetry selectivity in the hands of the well-trained writerly. Indeed, the greatness of *Rome*, of the civilized, the classical, the balanced, the golden mean, can be revitalized. Even in a time when everyone seems to strike the golden mean, there are some who can be said to do it better than others, and they have age-old credentials to prove it.

But remember: this is nothing new. The golden mean is always strived for. When Victorianism seemed too prudish, discursive, decadent and contained; while Romanticism seemed too spontaneous, impractical, and idiotic, early 20th-century modernism attempted to strike an even chord. It was refined, precise, economical, but also open (with its free verse musicality) and direct: neither too detached nor too emotional. After this became passé, the poetry of W.H. Auden in the 1930s struck a perfect new balance by welcoming in the political and interpersonal but without the maximalist hubris that the Modernist masters suffered when they attempted to do so. Think of Auden's recognition of human limitation, in the "ungrandiose" beauty of Limestones and think, too, of his gentle maxim: "love one another or die." His was a politics that never carried a big stick: "poetry makes nothing happen ... it survives, / A way of happening, a mouth" (1939). But the lack of grand redemptive poetic acts became THE poetic redemptive act of poetry in the footsteps of Auden. For

instance, the poetry of Elizabeth Bishop and the confessional school, which takes after the looser Lowell of the 60s, and Philip Larkin and the movement, which took to the commonplace and personal instead of the artificial. Doubting and searching and recognizing limitations: this was the new beauty. But it didn't mean running into arbitrary flights of fancy associated with a kind of flippant dandyism: this was a unitary, calming Zen-like recognition of instability. So poetry as a place for questioning the didacticism of poetry became the new poetry. And a looser, personal poetics was offered always as a balm for the maximalist hubris of the greater modernists. It is what gives Lowell his place (though he began with very formalistic gestures) and the style of the confessional poetry that emerges from his influence. Even the Black Mountain poets' emphasis on the breath, and the New York School emphasis on the quotidian take from Auden: the real is still located in the interpersonal, humane, and modest.

However, this poetry, in turn, was indeed, disliked by those angry post-structuralists of the 70s (Language poets) who found the quotidian and confessional vapid, formulaic, and apolitical: the interpersonal directness of the 'common man' was rejected in favor of the disfigured and fanciful. These poets looked for the zanier tradition of fanciful Romantics (Byron) and dark pre-Victorians (Poe), and also to the most radical modernists (Williams and Stein) to create an aesthetics of satirical gothic collage. Meanwhile, in the mainstream a lyrical devotion to the tradition of Lowell and Auden continued with informal suburban white male lyric poetry: Frank Bidardt, Robert Pinsky, Robert Haas, Billy Collins: personal poets, who were still, all in all, popular without relying on the academy or pop culture to prop them up.

Yet there needed to be someone who could stand in the middle, and be grounds for a new golden mean. Ashbery was able to be cooked and raw, conservative and radical, formally intricate and autonomous, popular-mainstream and avant-garde eclectic, playful-experimental-deconstructive, and lyrical-affective-interpersonal. So rather than participating in the sort of Oedipal overthrowing that kept occurring in poetry movements (we are raw and the last generation was cooked) he

simply did both at once and pointed no fingers. So, it makes sense that he would be the figure to be heralded as father to whatever next will be (the) golden (mean) in poetry. Indeed, the elliptical post-language lyric advocated by Stephen Burt sees him as an icon, as do the hybrid poetics advocated by Cole Swenson, even some Flarf poets studied with him at Bard (Drew Gardner and Brian Kim Stefans). Ashbery carries the torch given to him by Auden (literally in the form of the Yale Younger Poets prize) to give us a religious conviction of poetry that counts without being ever too arbitrary or too full of itself. However, it never falls into the sort of confessional identity politics formulaics that marks the Auden followers into the present.

Since Ashbery's lyrical followers have worn us dry with boringness (such as the hybrid and MFA poetries) and so have the more radical poetries that allegedly part ways with him (such as Flarf and conceptual poetry—those embarrassing stains on the bedsheets we can't get rid of, since their fundamental tactics are repeated ad nauseum by those in the more mainstream world of Alt Lit and those in the fringes of post-conceptual poetry). We need a new golden mean. Enter Dorothea Lasky.

Why Lasky? In part, because we are at the dawn of a new age, when white men are being overthrown as the benchmarkers of cultural importance. What I mean is that the next Ashbery can't be someone who looks like Ashbery. Though, certainly Peter Gizzi, Timothy Donnelly, and Adam Fitzgerald are all excellent writers. In contrast, the Iowa MFA canon of writerly white male poets throwing around the word "capital" in their poems is not up to par. Anyway, it probably can't be a gay male in the tradition of O'Hara either, since the modes of pop appropriation are simply too saturated in the mainstream. (Perez Hilton is simply better at doing what most gay poets try to do than the gay poets themselves—he's actually more crafty, smarter, wittier, and less reified.) What is needed is a woman we can envy and identify with, who is talented but flawed, relatable, self-deprecating, ironic, sincere, funny, and touching. What poetry needs is Lena Dunham sans Judd Apatow—with a classical elegance that points to a timeless craftsmanship and avoids the sell-out crassness.

As when queer rapper Lil' B raps about how much he loves the beauty of the world after seeing a little turtle, Lasky asks "why is a mouse sad," (74). This is an indication of what has been called Lasky's "Blood red realness" (*Boston Globe*). The animal she loves in these poems is dying, just as poetry is dying, the earth is dying, the wild, humane, feminine, and civil are all dying. But in the face of death Lasky shows compassion. The opening line of *Rome* makes it clear that she is not a bad guy: "Their bloodlust is what made them different from me" (1). Also on this first page: "All of it is because / Of how badly you lied to me" (1). As you can tell already, her words are plain, her expressions heartfelt, her discourse colloquial, never quite childlike or naïve but always hinting at that, and always simple pretension of systematic knowledge, especially when compared to the hyper-referential linguistic ballistics of Leftist poetries from Keston Sutherland to Bruce Andrews. She claims a non-macho eco-poetics.

As with Auden, interpersonal (and inter-species) sensitivity is privileged above political and philosophical rhetoric and above formal experimentation. And the upholding of a common decency, as Foucault has remarked, is always paired with an ideological fixation on the protection of a certain vulnerable group—here, dead animals.

Her sentiments and word choices are never particularly novel. "If somebody asks me what I like / It's not food or sex / It's looking for things and being in love" (4). And yet, even still, the lineation, rhythm, and sound sneakily allow these sentiments to flow with smoothness that is not a characteristic of ordinary speech. Moreover, this flow is consistent through the whole book and therefore one feels gently rocked when reading. This is not to say that the book does not dip into the quirky and slightly unexpected. It does, but those punctums come at an even pace. In the poem "Porn," we see the pattern of expected and unexpected play out: "And now I am crying / Because the man looks like an ex-boyfriend / Or my half brother / My boss / A monster / Someone who left me in the dark / Someone who darkened me" (7). Most of these lines are obvious but there are two quirky lines that seem to make up for it—"half brother" (quirky here because

it's not just a brother, it's a half brother) and "someone who darkened me" (quirky here because it's an ambiguous image).

This smooth flow of her plainspoken-then-quirky pattern will be a relief to readers who struggle to get through the enjambments and dappled overly sprung rhythms of experimental poetry. And yet this will also alienate people who expect a little noise and an extra rattle or two in their music. But if "poetry is hard for most people because of sound," (2) then in this case, the smooth sound will make this poetry quite easy for a lot of readers.

With new sincerity one hopes that the poet knows the difference between really bad and just sort of bad. We entrust the poet with a critical ability. "What is between us / Is an orange flower" (18). Can the flower be orange in 2014? Can the haiku style have any weight? Lasky isn't asking that. She is, rather, playing with the fact that it is unclear whether or not her poetics works or not. The orange flower, like the poem, is cute, interesting, zany but is it also beautiful, sublime, or genius? Lasky's champions insist indeed it is this: sublime, humane, moral, and symmetrical, despite or in spite of, its eccentricities. "It might be funny at times but it's really a very serious poetry." The problem of the orange flower escalates as the book proceeds to name colors so often that they stop penetrating the consciousness as significant. But then Lasky seems to know this, when she writes, "I feel pity for the colors" (79) or later when her colors are eaten.

> But death is the ultimate blissfulness
> To be a candy or a corpse
> The world holds you on its tongue
> And no one can save you
> Not even your own children or your friends
> So have a seat with the home of the dead
> They will eat your colors
> Until you are blank (28)

Here, again the usual pattern of going from simple very basic primary things, in common sense language, to the occasional quirky

line, works despite our rolled eyes. It works because the chords still strike that thing once called poetry. We admire someone attempting to revive poetry in a time when we are so cut off from the classical tradition. Yet poetry always seems cut off from what's before, even the Roman classical tradition was not acceptable to Heidegger, who thought Latin less authentic than Greek.

Lasky's phenomenological inquiries that border on the resurrection of a haiku-like concentration on primary experience sometimes work and sometimes fail. The poem "The Groveler" starts "you want me to abject myself / And tell you how grateful I am that you talked to me" and even though the poem gets more complicated in its imagery—launching into a surreal dream illustration of this first line—nonetheless it suffers from the same problem that confessional poetry has always suffered from: it can become, at times, banal. When artistic forms, including Alt Lit or confessional poetry, are attacked for being banal, I call foul. Of course, they recognize their own banality, but that adds to the confession of insignificance and resentment, which then attracts a sympathetic cluster of others feeling the same way. There is no naïve confessional speaker who thinks there is a big other listening to them, it is always people confessing ironically. Therefore, it is a mistake to chastise confession for being naïve but even worse to celebrate certain writers for being more ironic than others (like the sentiment "Tao Lin, now *he's* being ironic and aesthetic," as goes the tune of *Vice* article on Alt Lit as stupidity).

When one approaches poetic material that deals in the quotidian and flirts with banality, it helps to go in with some sort of historical and sociologically investigative armor. Celebrating one author over another in these cases is sometimes a dreadful mistake because it defeats the very pretense of your adoration of the 'democratic' virtues of the poet. However, for most critics who will get to this book, we are not dealing with the cult of democracy but the cult of genius (poetry will be made by some) and so we can and do forgive the axiomatic statements of grandiose praise for the author.

"I feel / Actually beside myself / Like beside my self / Like be side my self / Like really" (72). Lasky sits here with John Keats, who uses nature and phenomenology not to leap either into sentimental splendor (Wordsworth) or visionary eccentric chaos (John Clare, William Blake) but rather to offer matter of fact musings on reality and beauty. Lasky is part of larger trends than just New Sincerity; including Speculative Materialism and Queer Theory, attempts to return to the "great outdoors" that postmodernism has eaten up. Though still dressing in an over-the-top hipster garb, and speaking in an affected voice—Lasky nonetheless gives us some form of sincerity that can make us feel connected again to the "black life" that we have attempted to banish. She returns us to death, the human, the humanistic, the humane, the sacred, but never in such a way that throws total caution to the wind. Lasky gives us emotion recollected in irony and in *Rome* irony is tranquility.

The Prison House of Post-Internet Art

Deconstructing the New Museum's 2015 Triennial

Post-Internet art is now acknowledged to be a highly marketable form of multimedia art that extends some of the aesthetics developed on the Internet, with the difference that this art can fit the gallery environment as objects that can be bought-and-sold, in contrast to digital art that unfolds temporally on websites.[1] While looking good on social media (click-bait art), post-Internet art is also widely acknowledged as superficial. Whether it's because the art needs to be darker, more humane, craftier, more rigorous and dialectical, wittier, self-reflective, or linguistic; the takeaway seems to be that it's just not sharp or critical enough. The other common criticism of post-Internet art is that it is a sell-out version of innovations that were originally made online by geeky net artists who are simply too oddball to play the art-world game. But here's the real problem: after many art critics and curators defame post-Internet art, they go on to promote nostalgic revisions (return to craft or subjectivity) or else radical versions (more negative or critical) that do not serve to break out of the post-Internet canon but merely add to it. Or else critics and curators just put forward a less popular post-Internet artist in place of a popular one, erecting their own canon of post-Internet art without confronting the bait and switch. Rather than admitting that they are making a hierarchical claim for a new crop of geniuses based on their own whims,

1 Karen Archey and Robin Peckham, "Post-Internet refers not to a time 'after' the Internet but rather to an Internet state of mind—to think in the fashion of the network." *The New York Times*, <www.nytimes.com/2015/02/08/arts/design/new-museums-triennial-is-all-about-being-wired.html?_r=0>. A fairly good introduction to this work is at <artspace.com/magazine/interviews_features/post_internet_art>.

these critics and curators will often say their decisions are based on an appeal to a queer or collectively critical impulse.

These revisionist interventions fail because the critics and curators in question are not able to rid themselves of the zeitgeist artists who make them uneasy, nor do they free themselves from the arbitrary judgments they censure in others. Rather than find a critical position that can accurately deal with the work they like and reckon with its good and bad traits, such critics and curators mark the post-Internet art works they like as exemplary, austere, astute, subculturally hip and/or self-critical.

Curator and former director of *Rhizome*, Lauren Cornell argues repeatedly for negative critical art in interviews but then chooses mostly pop-friendly relational works in The New Museum's 2015 *Surround Audience Triennial* (February 25 to May 24, 2015). This work may be thoroughly enjoyable or thoroughly irritating depending on the reviewer, and in that sense, it exudes what is best and worst about post-Internet art. But what it doesn't do is offer any sort of real challenge to its fundamental aesthetics.

In an *Art in America* essay, curator Brian Droitcour critiques post-Internet art for being too trendy and trivial, but then curates a show with safe, mostly sophomoric art. His exhibit, "Thanks to Apple, Amazon, and the Mall," (January 6 to February 8, 2015) and book series for Klaus Gallery (NYC), as well as his poetry book for the *Triennial*, consist mostly of rehashings of post-Internet Art. In "Mall," for instance, all the post-Internet art staples are there: derivative language experiments (the first wall you see has written in big letters: "Deserted beaches / This thong no longer fits me / I've grown a large dick"), cutely over-sentimental confession, online lingo, not-so interesting painting, hip and fashion-forward packaging, etc.

Post-Internet art seems to forge a kind of prison house, so that even those claiming to be critically outside of it or romantically outside of it seem to be glued to its platforms, canons, and sales pitches. On the one hand, post-Internet art, even in its allegedly dark or witty strains,

Installation view, "Thanks to Apple, Amazon, and the Mall,"
Klaus Gallery (NYC) 2015.

is easy to spoon into the mouths of the public and the gallerists; on the other, it is hard to convince the intelligentsia (who give art its prestigious distinction from mass media) that this work is any good. So it becomes the job of figures like Droitcour to select work that rises above the alleged banality of post-Internet art and to do whatever theoretical maneuvering possible to support this claim, while continuing to sell work that really *is* post-Internet art. It's the emperor's new clothes style bait and switch, which we all kind of know is going on but adore because in the end it gives us what we want (to see the emperor naked: sex sells and so does the banal).

The press release for "Mall," claims to account for "spontaneity, conflict, failure, and decay,"[2] but the work shown hardly represents these qualities, which aren't really all that hard to represent (a drawing of squiggly lines, a video that documents psychological strife, a corpse-like or scary abject object like meat—something actually decaying, or stinky). And then there is the claim that unlike post-Internet art, this

2 "Press Release." Klausgallery.com, <klausgallery.com/exhibition/thanks-to-apple-amazon-and-the-mall-curated-by-brian-droitcour-2015-01-6/#pressrelease>.

work has "a spirit of criticality, an oblique sense of humor, and yes, a high tolerance for stupidity."[3] Self-criticality, humor, and ironic stupidity are all 'everyday' parts of our culture. This was the problem I had too with Amalia Ullman's rise to fame for having a 'manufactured' sugar baby persona; as if the fact of the 'manufacture' made it somehow more revelatory or critical than the personae of bonafide sugar babies, who seem plenty self-critical.

The idea that emphasizing the accidental is somehow humanistic is not only naïve but also banal; all of Alt Lit and Net Art functions from the premise that there is something juvenile, accidental, weak, and sarcastic in the great millennial artworks. The sexually curious AOL Instant Message chats by artist Ann Hirsch (collected from her teenage years), published by Droitcour by *Klaus e-books*, while interesting as cultural detritus, are hardly differentiable from the troves of Net Art and Alt Lit that have existed since the 1990s. Not that there's anything wrong with that. It is actually the indifferentiability of this art—not from mass media, but rather from net bohemianism (and its ready-to-wear blends of sarcasm, irony, and off-kilter humor) that makes it so delightful. But if this indifferentiability were admitted the sales pitch would disappear.

Kenneth Goldsmith has certainly hinted at the fact of ubiquity by saying poetry will be made by all, but he has kept his tongue firmly in cheek, and praised only a select few artists and poets in this process. Hans-Ulrich Obrist seems to take this joke very literally and his 89-plus Foundation is actually conceived of as a 'utopian' project (and that's what makes it so dystopian).

Goldsmith, Obrist, and Droitcour have all spearheaded recent attempts to bring poetry into the gallery. One of the key selling points is the claim that poetry signifies a kind of flux indeterminacy that destabilizes canons or essentialist genders. This is a naïve idea of poetry, performance, and expanded cinemas inherited from the 60s but

3 Media Farzin, "Thanks to Apple, Amazon and the Mall," *Artagenda.com*. February 4 2015 <www.art-agenda.com/reviews/%E2%80%9Cthanks-to-apple-amazon-and-the-mall%E2%80%9D/>.

repeatedly debunked since then. Add to the pot "the Internet," which is now also taken up as a utopian global village of indeterminacy, as when Cory Arcangel writes,

> The term that really drives me up the wall, though, is web page. Page connotes something stable, unchanging, and definite. A book page exists. A book page is. A web page, on the other hand, is a vastly more complicated structure. It is a set of instructions blasted from a server farm across the globe through fiber-optic cables, then interpreted by a computer's hypertext transfer protocol browser and displayed by a light-emitting-diode screen. All this, by the way, is happening in real time—reconstituted at each millisecond through a unique and contingent tangle of systems—and is supported by the constant churn of the power grid, itself (incredibly) still commonly powered by burning coal. So instead of web page, I'd prefer the term web performance, which would remind us that this information is both immediate and ephemeral. In a sense, it is thousands of coal-powered virtual Rube Goldberg machines—lined up from end to end—that power our Facebook Paper apps on our iPhones.[4]

Much of this naïveté (with its false assumption that book technology creates stability[5]) was renewed by Seth Price's canonical essay "Dispersion" (2002), which suggested that art works that disappear into media networks would subvert the object fixation of capitalism; not to mention MFAs in Performance that overemphasize art world performance as subversive. But as soon as someone can be noticed for disappearing, that disappearing ceases to be all that destabilizing. This mistaken notion crystallized with David Joselit's *After Art*, which claimed that the injection of the network, the meme, fluidity, and dispersion into the museum was somehow subversive to heterosexist patriarchal stability in the art market. This idea was increasingly de-

4 Cory Arcangel, "The Warhol Files: Andy Warhol's Long-lost Computer Graphics," *Artforum.com*, July 2014 <artforum.com/inprint/issue=201406&id=46874>.

5 Jerome J. McGann, *The Textual Condition*, Princeton: Princeton UP, 1991.

railed, the more his book became a catalogue of artists, all of whom had work that could easily be bought and sold.

The drama between material object and immaterial network is the underlying tension at play in Ed Halter's appraisal of the work of Net artist Guthrie Lonergan in *Artforum*: "Lonergan's work could be seen as a realization of [Seth] Price's proposal. But Lonergan reverse-engineered Price's prophecy. Rather than starting out as a gallery artist, then moving on from that context to exploit the mechanisms and forms of mass media in creating and disseminating his art, Lonergan began his work online and only later attempted to adapt his practice in order to participate in meatspace exhibitions."[6] Lonergan by being successful at 'failure' becomes a valuable statue in the wax museum of obscure hip artists. Then Halter's conclusion, "It's as if Lonergan has dissolved back into the flux of online media from which he emerged, now just another Internet user among billions,"[7] which is bizarre because if he had disappeared then it was only in such a way that it would be remarked upon by a leading expert on the topic of Internet art. Which means he didn't really disappear at all.

Though Lonergan might not have disappeared, Halter's description of his disappearance serves as a threat: in the world of Net Art and post-Internet art, talent is a dime a dozen, so any artist playing this game is flirting with obscurity and banality. However, the critic always remains on shore, in the most secure position of all, though perhaps without the same glamour.

Let's bear in mind that artist Paul Chan, much associated with post-Internet art, recently switched to "nonprojections" when it became increasingly evident that anyone could and would do the sort of art he was doing. Additionally, many scholars and curators have to switch modes after pumping up post-Internet artists to claiming that there is really only a select group of interesting ones who were always actually "against" the trend that they helped to put into place. Thus

6 Ed Halter, "In Search Of: Ed Halter on the Art of Guthrie Lonergan," *Artforum*, November 2014.

7 Ibid.

many will disavow a connection to ideological figures that stood for a perhaps all too innocent net utopianism, such as Gaga or Ryan Trecartin, both of whom are interested in a kind of cyborg gender play that is allegedly liberatory.

What we have here is a binge and purge cycle: where we binge on an Internet sensation from Gaga to Trecartin to *American Horror Story* or Tao Lin or Terry Richardson or *American Apparel*: enjoying it because it feeds our addictions, and because there is no commercial break anymore, so we don't have the time to critically reflect, and then as soon as it slips up or grows old or does something truly "offensive," we burn it at the stake—blaming the object for our own mediocrity, our own 'choice' to repeatedly enjoy the lowest and stupidest forms of culture possible. Then we respond by pitchforking with memes and hoping that we can be freed by getting rid of this "perverse guy," or this "boring, derivative artist," and move right on to the next show on the Netflix queue.

The uglier truth is that Trecartin did indeed show some kind of genius in his early videos despite the fact that they were compromised by the very same sort of neoliberal 'cuteness' that they might be critiqued for now. However, his singularity is hard to see beneath the opportunistic pastiching of John Waters, experimental poetry, and YouTube vlogging that seemed to be a symptomatic reaction to RISD culture where poetry and subculture and design and Net Art could all come together into ur-objects for millennial museums. Thus, there is something to his work that is symptomatic of a new phase of the avant-garde, where sites like *Ubu* can amalgamate much content from different fields and make them available to people who would typically have needed to be in an elite bubble to learn about this material. The genius of Trecartin's work requires that one look beyond the pastiche, the borrowing, the symptoms of a democratized avant-garde, and the banalization of certain radical postmodern procedures (from parataxis to deconstruction to cyborg drag).

Rather, in Trecartin's editing there are little whimsical choices that are made that suggest genius and singularity, certain choices in where

BIG PRINT

HOLY BIBLE

HALLELUJIAH
miss charlemagne

MODERN ART GO AWAY GO OUT MISS PROVIDE
you/why a line 're afraid DO CHARLEMAGNE CALL OMIT *not too late* STOP
TEMPTING FABLE WHY Thinking all these GO OUTs are for me run out but
PARTY *not you* SIS in the hall you wait *hear the phone* Nijole calls get back to
answer PHONE JUST IN TIME C she wants to check the ring on her phone, not
enough TIME *reason call Nijole* A CALL JASPER JOHNS *IT WASN'T*
important WHICH CANT STOP L cant tell what to *finish* do *so important*
basketball YOU CAN CUT IT see M call Nijole often who is *not* Ding a ling
stop TAKE A BATH on a 45 degree angle red light HESITATE so *filling* the tub
Accomplish BED in frame for Raymond's drawing 5 DOLLARS *save pennies talk*
to mother type walking by hardward store little lamp says 2:30 go in, it's 2:30 red
BUY IT NOW *tensor* but it's making you stop *me* what it started me doing so I
buy it 3.50 *bulb* BIRD DO THE MUSEUM STIFF stuff WHAT Every-
thing seems to be *negative* five dollars more than *pronoun* CUT IT SHORT
WHYS says OUT asked about a table see 40 price 45 NO HANNAH DUNGA-
REES pronoun's are used cost $3 *much quieter* energy than the DUMB grey
corduroys HOW ARE YOU *free pants* LAMONTE FEEL washing

(A L L M E running down the left margin of the text block)*

Hannah Weiner, *Clairvoyant Journal*, 3/15/74.

Ryan Trecartin, wall text for *New Museum Triennial*, 2015.

and when the image dissolves, that are fresh and genuinely eccentric, in a world of otherwise mostly imitative procedures (the fact that it is about a world of imitation, i.e., everything is a simulacrum, is itself a highly derivative ideation). That is to say there are still singular marks in his works, particularly in the early videos. His latest videos seem to rely too heavily on the highly dated routine of making fun of cheerleader valley girl talk in a rather routine fashion. Moreover, his poems for the *Triennial*, a different one for each floor, are charming but they would hardly garner attention from informed poetry readers, as they seem too derivative of earlier experimental poetics.

Likewise, while an art critic might find Hirsch's Klaus e-book interesting, a more informed reader of poetry and fiction would likely disagree. Cornell writes of the e-book, "how identity and desire form in a culture encircled by social media" and "Its originality defies easy classification"[8] but there is a long line of artists using social media to produce art, for example, the Flarf collective and Rob Fitterman (namely the late 90s). And yet here critics and curators apparently uninformed by related developments in poetry, who assume the same ignorance on the part of their audience, are chalking it up as new. Just read the manic baroque poetry of Nada Gordon or the hilarious crude poetry of Gary Sullivan and then look again at these word works. And yet Cornell is aware that experimental art has become ubiquitous, as she notes in a conversation with Ed Halter in *Mousse Magazine*: "The expanded art market has lured celebrity interest into its VIP echelons; rappers are reflecting on the canon; pop singers self-identify as individual avant-garde movements."[9] She tends to like art that has a dystopian acknowledgement of this, as Trecartin comments "I think I look at the way things are changing more from an optimistic standpoint, and Lauren tends to see it more from a dystopian one, but the older I get the more complicated my own views get."[10]

8 <www.klausgallery.net/ebooks/hirsch.html>.

9 Ed Halter and Lauren Cornell, "Mass Effect," *Mousse Magazine*, <moussemagazine.it/articolo.mm?id=1054>.

10 Randy Kennedy, "Where Virtual Equals Real," *The New York Times*, <nytimes.com/2015/02/08/arts/design/new-museums-triennial-is-all-about-being-wired.html?_r=0>.

But whether one puts a dystopian spin on this or utopian one, there seems to be a failure of imagination on the parts of Cornell and Trecartin, among others, to think through work that is outside the inflated bubble of post-Internet art. Much as queer theory has a negative and positive strain but is nonetheless restricted to the same underlying base structure of institutionally mediated identity politics, the dystopian (German critical) and utopian (French relational) sides of the art world coin both seek to find works that are able to represent and reinforce contemporary middle-class identity. The only argument is over whether or not that identity ought to be configured as critical or joyous.

To me, at least, the utopian side seems particularly odd, especially in its Marxist variations: what exactly does the highly aristocratic zone of art sales have to do with Aaron Swartz or efforts to structurally redistribute information? And yet these two are tied together repeatedly. The dystopian side, which openly relishes corporate sponsorship and reification, is not necessarily any smarter, though, simply because they are often old hat. If the avant-garde becomes so disseminated that, like psychoanalysis, it becomes a clichéd staple of the entire literate first world then that will mean everything and nothing. Everything because everyone will be "talking about it" and nothing because it will never fundamentally alter or disrupt the base; whether you think the base is economic inequality, or the inevitability of intellectual hierarchy.

Cornell often finds herself defending what she has just theoretically put down: "Cortright was one of the first to utilize behaviors emerging from YouTube, specifically the uploading of diaristic first-person videos to an anonymous public. And the persona she created, one that amplifies and plays with the narcissism of social media, remains subversive and confounding today, even as this 'way of being' has become totally widespread (see obsession with selfies)."[11] But how has this remained subversive? What is it subverting? Is it nostalgia to like these works? This unqualified praise is difficult to parse out and seems like mere product placement.

11 Ed Halter and Lauren Cornell.

In this same conversation, Halter disparages *DIS* magazine: "I person-ally can't see any important difference between *DIS* and so many oth-er fashion publications; to me, any distinctions between *DIS*, some-thing like *Nylon* and then *Vogue* are simply matters of style and scene. They're all winking at consumerism while celebrating its emotional effects and the pleasure of its surfaces, and they all give their own kind of shout-outs to the art world. And because of this, *DIS* doesn't particularly capture my interest, despite the fact that there are individ-ual writers and artists I really like and admire who have been brought into their fold. I felt the same way about Bernadette Corporation. I understand that this line of commentary might be interesting to oth-ers, but to me, it's like conceptual insider trading."[12]

This is a perfectly well argued point. My problem is only that Hal-ter doesn't then articulate why he doesn't also disparage k8 hardy or Cory Arcangel. When critiquing *DIS* magazine Halter is lucid and astute, but in his endorsements of artists, he sometimes lapses into the sort of stance that he criticizes.

The idea that the singular or whimsical can be isolated or discovered by a curator in a way that is different from our everyday experience of the Internet is a sales pitch. It is was easy to critique the *Forever Now* painting show at the Museum of Modern Art for its silly theorizing in describing the work at play, nonetheless the correction has been to say: "hey there's a lot more going on that they didn't show." But this always still counts on a more inclusive but still existing future canon to come save the day. The denigration of singularity has nothing to do with the death of the author but rather the inflated discourses that prop up certain styles that are most familiar and the repression and disintegration of styles that are least familiar, least MFA, least art-poetry-culture-in-a-blender.

In 1999, Tan Lin developed the notion of "ambient stylistics," which has provided an entrance for the conceptual poet into the museum. Internet poetry as a cohesive genre can be marked as beginning in the early 2000s with Flarf. It was popularized on a larger scale with Alt

12 Ibid.

Lit in 2006. Though, one should note that in the 1980s bp Nichol had already mastered digital and computer poetics, and in the late 1990s Internet art and poetics was already mastered by Brian Kim Stefans, and not much of the "newer" stuff has surpassed or updated its aesthetics. In 2009 Internet art came into fruition with the *Younger than Jesus* show at the New Museum, which made Trecartin a global art brand. A post-Internet sensibility, forever burbling within this cauldron, really came together in 2015, with the *New Museum Triennial*: finding a way to take the notions of Net Art and Internet poetry and combine them with an ironic (and plausibly critical) art-market-friendly position.

Harry Burke curated a web portion of the *New Museum Triennial* called "Poetry as Practice." Since most articles about post-Internet art are simply lists of 'cool people,' I want to pause for a moment and consider an actual work by Burke—this one, a poem called "wednesday," starts: "Time is really long :(/ time is like a thing," and ends "Depressed people don't remember happy times. / At least not specifically. / tend to be too vague."[13] Burke's style, apparent in this essay, is what I would refer to as O'Hara 2.0, taking confessional day-to-day style, reciting it somewhat ironically, and keeping it up to date with references. It's quite plain, and lacks innovation, or differentiation from the many other O'Hara 2.0 poets. And often I have this experience. I'll see a cluster of poets with huge Twitter followers and museum/gallery recognition but when I look up their poetry, I find nil in the way of interest or innovation. Of course, this is never noticed, or noted. Nor have I seen any critical feedback on this style. It rather passes as the gallery, museum and hipster norm—good networking, so-so writing. To be blunt, we have to start learning to see that post-Internet poetry is merely conservative and middlebrow poetry—just as *Vice* magazine is just the new *New Yorker*. The bastion of mainstream/middlebrow/academic poetry has deflated and in its wake are only the post-postmodern coteries that are as gutless as 20th-century lyrical laureate wannabes.

13 Harry Burke, "Two Poems," *The Quietus*, <http://thequietus.com/articles/13600-two-poems-by-harry-burke>.

If we are in an age where reading is dead, that is only because we are in a world where word-of-mouth and coterie feeds curatorial choices more than actual analysis and critical 'reading' of artworks—we see a world that is simply not substantively engaged with a range of diversity in practice and material. One can certainly 'read' an object for its innovative potential, and relationship to historical precedent, (as well as aesthetic form), but this is an intellectually worthless exercise, when in the wrong hands.

Burke's description of "poetry as practice," does not even seem to have entered the 2000s: "'Poetry as Practice' considers online poetry as a process embedded in material, technological systems, and everyday, embodied experiences.... this hybrid approach, poetry is considered as media, and digital media—which can be thought of as a linguistic form or computer code—is activated as poetry.... Whether it's in the use of vernacular styles...rule-based composition.... Or self-erasure... the poets downplay individual authorship and underscore the influence of the surrounding conditions that shape their work. However, they refuse to be over-determined by these conditions: the works are often introspective in their approach, systematically yet lyrically evoking particular moods and points of view."[14] This is textbook digital poetry theory from the 1990s verbatim.

There is nothing wrong with poets doing well in the art world. It just brings about several structural problems that cannot be ignored, as it is quite simply a more economically elite world than poetry's. It is especially wonderful when a poet and artist like Etel Adnan, goes from being relatively unknown in the artworld to being featured in the *Whitney Biennial*, and becoming the talk of what Jack Smith called "the cocktail world." (Case in point, her poetry was highlighted as a "need to know" item in *Vogue* magazine online, of all places.) This is welcome for many reasons; her work deserves to be spotlighted as much as (if not more than) trendy younger artists. Yet this comes with the structural problem—too often radical women artists tend to be

14 "Poetry as Practice," *New Museum*, <http://www.newmuseum.org/exhibitions/view/poetry-as-practice>.

better received only when they get older or die (consider the careers of Carolee Schneemann or Nancy Spero).

It is equally exciting to see younger poets who deal with art and Internet getting relatively significant praise that is fairly unprecedented in the history of experimental poetics. Andrew Durbin (born 1989), who wrote for the *Triennial* catalogue, has been a kind of poster-boy and impresario for this turn. After reading at "Poetry Will Be Made By All," he caught the attention of trendsetter Hans-Ulrich Obrist; and this past year his book *Mature Themes* had its launch at the New Museum. Durbin's style is very similar to the long tradition of New York School poetry that has slowly encompassed the Internet. Ben Fama, a few years his senior (who runs Wonder Press with him) sort of brought this style together. Fama's most recent book *Fantasy* (Ugly Ducking Presse) is filled with light blasé confession that is very California chill, and full of tongue-in-cheeks youthful jargon (references to Forever 21 and YouTube abound). Yet it is also mixed with a vaguely sincere location-stamped "I did this, I did that" New York School vibe: "They flirt through text and social media, grafting their lust onto a tenuous mutual experience they shared at Avenue in the Meatpacking District during a mutual friend's birthday"[15] and "it was april / i was slow / with my camera / dev hyenas / it was warm / after winter / you said / feel the world / against your skin"[16] and "I love summer, the luxury of poetry, gin / and tonic, quinine lost in juniper."[17]

This style is quite similar to Durbin's, see: "the Easter light a pale beige / over the city as I speed / up on the BQE / (as the cab speeds / up on the BQE) / with the sun fallen / in its blue / behind me. I remember / you vomiting on me / last night / in the cab / and for some reason / I thought it was / really cute."[18] My problem with this style is that it is advertised so heavily as 'new' when it is mostly more

15 Ben Fama, *Fantasy*, Brooklyn, NY: Ugly Duckling Presse, 2015, 75.

16 Ibid, 72.

17 Ibid, 80.

18 Andrew Durbin, "Lil Emoji." *thevolta.com*, September 2014, <thevolta.org/ewc45-adurbin-p1.html>.

of the old with updated *references*. Much of the theoretical summations do not interest me, "We live in a joyous age. By which I mean all is available to us. And while life under the imperative to enjoy the self-annihilating transmission of our bodies elsewhere as we conform to it remains cryptic in its universal demand that we rapidly cycle through all that we adore, all the time, its moments of clarity are just as preciously encoded into the bouts of 'feeling' that mark these times as are its moments of obscurity too."[19] This is merely another restating of the "imperative to enjoy" theory that has been one of cultural theory's most famous concepts since the late 90s. In general, the Frank O'Hara 2.0 style does make for entertaining poetry but it is hard to call it innovative—which makes the praise from art world heavyweights like Obrist or Stuart Comer seem to be more about the fact that the references are contemporary than anything else. And maybe this is Durbin's greatest cunning: the book is chock full of product placements.

Yet, it is becoming a commonplace perspective that the ironic or cunning use of product placement in art, rap, pop culture, fashion, and poetry is too pervasive. If the unprecedented boom of the global art world in the new millennium has meant that insider art-world information is becoming mainstream gossip, while ironic-sincerity is becoming quotidian; than the singularity of certain art objects has not 'vanished' but simply moved on elsewhere. Meanwhile, the art world has its record stuck on repeat. The New Museum's poetry book accompanying their show (edited by Droitcour) features "intensely personal diaristic lyrics that update confessional poetry for the age of mass surveillance; conceptual and post-conceptual practices of appropriation, deletion, and revision that configure writing as a kind of data management [and] blog posts, status updates, and tweets from some twenty contributors to characterize the poetic potential of everyday language,"[20]—Nothing could be more common. Nowadays, even

19 Andrew Durbin, "My Love Don't Cost a Thing," *Imperial Matters*, <imperialmatters.com/andrew-durbin/>.

20 Dan Durray, "New Museum to Publish 2015 Triennial Poetry Book," *Artnews*, November 2014, <artnews.com/2014/11/17/new-museum-to-publish-2015-triennial-poetry-book/>.

children using Facebook have a sense of the ironic, sarcastic, and detached.

Simply having an awareness of the circuitry of surveillance (whether it's the panopticon or the hidden microphone) is not particularly new. The relationship of the self to digital technology is at least as old as Rosalind Krauss's "The Aesthetics of Narcissism" essay on video art and Vito Acconci. After all, even a diary is dedicated to "you," and the impartial spectator always looms over confession and self-referential art (the epistolary novel being just one very good example, religious works with God above being another).

If Droitcour is interested in a poetic use of social media that "eschews slippery efficiency and disposable virility" it is not clear that the artists and poets he endorses are doing this. Roggenbuck and Trecartin, are, on the contrary, incredibly web efficient and viral. Most poets that have had crossover success as artists recently have done so because they are highly enigmatic and know how to catch 'our' attention on the Internet and play the game. They are absolutely never hostile, introverted, autistic, schizopoetic outsiders. The romantic insistence returns (as it does in Joselit's after art, or Price's dissemination, or Arcangel's idea of performance versus page) that somehow poetry on social media is less corporatized, regimented, or solid than the 'hard page' was. This ahistorical conviction reminds me of the age-old privileging of the performative voice over the textual inscription. Though here, basic science disproves the binary: book pages can burn just as hard-drives can crash but never in history has this many people's writing been this archived or corporatized; so if anything the reverse of this binary is truer: poetry and the archive, is growing harder, and less liquid—even as it grows to accommodate more of the planet, and 'queerer' people. One doesn't have to read a book on neoliberalism to understand this.

To historicize his argument, in his catalogue essay on "Liquid Poetry," Droitcour makes a leap of sixty years, from concrete poetry to the present, complaining that the former was too removed from the fluidity

Décio Pignatari, Beba Coca-Cola, trans. "drink/drool/drink/drool/ shard/glue/coca cola/glue/coca(ine)/ glue shard/c e s s p o o l," 1957.

Street advertisement for *New Museum Triennial*, 2015.

of self; too sculptural; "its mentality holds poetry as always external,"[21] then acts as though this 'sculptural' version of poetry wasn't smashed until this *Triennial* thought to include poetry. Now, you don't need to be the son of a Language poet to recognize that people have been interested in the dematerialization of language arts for a very long time, even and especially in the art world (think of Lucy Lippard for one). Moreover, to jump from a specifically Brazilian avant-garde tradition that had only a very loose connection to institutional authorities and museums (and one of the few canonical example of South American twentieth-century avant-garde poetics) to a bunch of mostly North Americans using Twitter—young North Americans who even prior to this catalogue had already received institutional attention (not just from Twitter, through followers, but also from galleries and museums and fashion magazines), seems like the reverse of the liquification he is describing. Besides, as pictured above, one of the most iconic examples of concrete poetry is all about liquification, "Drink coca cola / coca cola shit": not only does it find poetry in the unexpected and everyday but it also points literally to body fluids and conflates them with coca cola, the secretion of Western capitalism, and America's massive global export.

21 Brian Droitcour, "Liquid Poetry," *The Generational Triennial 2015. New Museum Triennial 2015*, Ed. Lauren Cornell, New York: Rizzoli International, 2015.

Droitcour's statement: "to think of poetry as liquid means to realize that poetry can have form, but the form isn't set or predictable or germane to the poem,"[22] is wildly derivative of each modernist and post-modernist wave of poetry, and seems willfully unattributed. But he also romantically waxes on about the poetics of everyday life, seeing and hearing poetry in everyday things, which is a cliché that is found in even the most mainstream bastions of poetry, and perhaps that is what he likes.

Though Droitcour brushes it aside moments later, for a second he reveals what is going on with poetry here: "This could just be a function of fashion's cycles, or the art world's constant need to replenish itself with novel disciplines and the revival of older, half-forgotten interests."[23] Yes, that's what it is. But is it even half-forgotten or just being willfully ignored?

Finally, Droitcour relates this idea of liquid poetics to the queer person's self-presentation, namely Juliana Huxtable: "What interests me is the relationship between an unfixed identity and the ambiguities of poetic language—the capacity of language to mean many things at once as a way of enabling a person to be understood in all of their nuances and complexities."[24] Moreover, the claiming of one particular body, namely Juliana Huxtable's, as an index for a poetic philosophy about liberation, and to offer no reason for valorizing this body, except vis-à-vis its connection to a museum exhibition, is at once apolitical *and* anti-aesthetic. Is it really so much for me to want to see a varied, historically astute and aesthetically based argument for why selections are made (i.e. why one seapunk painting versus another; why one capslock poem about identity versus another)? This requires comparison, as well as the acknowledgement of ubiquity, but it is a starting point for finding singularity. Otherwise, we are granting special privilege to artists just because they are queer, young, or good-looking—a kind of coddling that masks as politics. The coincidence of Droitcour's claim

22 Ibid.

23 Ibid.

24 Ibid.

Installation view of Frank Benson's statue of Juliana Huxtable at *New Museum Triennial*, 2015.

of liberatory flux with the moment a certain subculture and identity is finding its commodity form seems to be nothing more than cashing in. Of course, it is good to make some money every now and again, but we still might also look at the question of who gets to represent queer politics for fashion, museums, and the mainstream. And even more importantly, who chooses the representatives, builds the theoretical indices, writes the catalogue copy, and signs the checks. These aren't merely questions for the voters on *RuPaul's Drag Race* and the photographers at *Vice Magazine*, but also for those of us interested in critically reading that American fetish called commodity and not just buying its latest goody bag.

What is new (and a departure from postmodernism) about millennial art is that it seems to be 'bringing back' the self *after* the ruptures in the proscenium that modernism and post-modernism brought. This new sincerity is a return to spectacle but with just the right amount of 'irony' and 'detachment' to make it permissible to the intelligentsia (and our own superegos). What is also unique about this moment is

that postmodernism and the banalization of spectacle has been glo-
balized—though this was clearly predicated by Baudrillard and the Pic-
tures Generation artists. The class inequality remains after the global-
ization of Western sensibilities and this inspires the most politically
'ethical' artwork in the show: where Chinese artist Li Liao goes under-
cover as a factory worker (at a notoriously grueling gadget producing
factory) and, after weeks of work, can only afford one iPad. But the
problem here is the notion that a Western-acknowledged artist going
undercover can help us to better think about the problems of wage
labor than a news story.

The *Triennial*, as a whole, is a vivid encapsulation of the negative and
positive poles of queer theory. One group of the works are cynical,
anti-futuristic, relentlessly recognizing reification; the other group of
the works are utopian, future-forward, cyborg-positive, anti-hierarchi-
cal, and communal. The positive side is embodied by Frank Benson's
statue of DJ, writer, and artist Juliana Huxtable. This statue elegantly
concretizes the queer Brooklyn fashion of the moment, taking this
temporary, nightlife-oriented culture and giving it permanence, grant-
ing it spotlight in the Western canon of idealized statues. The work
doesn't really trouble canonical representation of queer identity. As
a result, it is an easy piece to pick out and celebrate in magazines
that wish to seem cool, fashionable, zany, and leftist. The sculpture,
like Huxtable, is stunning, and comes replete with dreads and an an-
gry inch. And like Huxtable's writing (featured in her kaleidoscopic
paintings), it puts confessional queer self-promotion and inquiry into
art without much alteration—treating the queer identity as a ready-
made. The only problem is this: Why is this queer identity more stun-
ning or interesting than any of the others? The only way to properly
assess and judge queer personae at this moment seems to be through
beauty-pageant tactics not dissimilar from *RuPaul's Drag Race*. Thus,
the rise in fame of one or the other queer performance artist always
seems to be flimsily held up by a very mainstream set of standards;
mostly emphasizing attractiveness and buzz-feedability. Enter the neg-
ative pole ...

The negative pole emphasizes suspicion, paranoia, self-parody, irony, and criticality; it is epitomized by the contribution by *DIS*, an organization that has always been acutely upfront about a commitment to complacently pointing out the reification and corporatization of art and subculture. What is not usually fully apprehended by the negative side of queer theory is that 'negative' affects (such as suspicion or depression) help grease the wheels of incorporation and do not serve to disrupt the machinery of capitalism but rather helps grease the wheels. *DIS*, in contrast, is able to wickedly understand this. However it, too, has something of an optimistic tone: it valorizes a particular rubric of criticality, detachment, and irony that, like all fashion, if practiced well can offer some form of self-improvement (the end game is fitting in and making money). But what the *DIS* group intellectually understands—that the banal, the basic, and the normative is always the destination of the subversive, especially when it is collectivized or corporatized—does not save them aesthetically. And since they desire to have a differentiated brand, they need aesthetic taste to guide

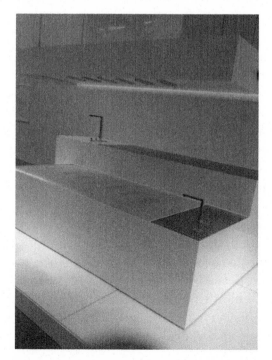

Installation view of Kitchen Bathroom by *DIS* at *New Museum Triennial*, 2015.

them, and thus there is pathos when their 'singular' contribution to
the show finally does not have anything remarkable about it.

The incorporation of self-criticality or gender-fluidity into the cold
machinery of the canon does not fundamentally alter the museum
nor does it necessarily produce aesthetically interesting works. *DIS*
claims to be neither high nor low but medium—yet there is nothing
medium about this claim. This claim is high, related to longstanding
claims of high fashion and high art. However, it is not high enough.
The recognition and incorporation of the banal into the art object
(and vice-versa) is simply too rehashed from early avant-gardes (and
even earlier proto-avant-gardes) to be remarkable—the 'sleazy' and the
'mediocre' are always going to be conceptually interesting to think
about but are not necessarily going to be interesting to behold. There
is a higher 'brand' of singularity that could be at play here...but it's
nowhere in sight.

The *Triennial* vis-à-vis Cornell's dystopianism, Trecartin's utopianism,
and Droitcour's exceptionalism has delivered, yet again, the mediated
self or the post-Internet self (or really, the post-Cartesian self). So this
is cause for exuberance or dismay, both affects illustrated well by the
exhibition. Even though we have our referential utopian art and our
anti-referential dystopian art, and it's all perfectly up to date, with
the latest positive identities and negative critical positions represent-
ed, still, something's missing. Or maybe ... nothing's missing. Maybe,
in fact, *DIS*'s Kitchen-Bathroom, which can barely issue a use-value,
exchange-value, or an autonomous aesthetic-value, has not only one-
upped Duchamp (by deleting aesthetics) but also anticipated and can-
celed out the need for my critique...and maybe that's why I found this
Triennial so *DIS*-couraging.

Indeed the "new" claims that museums have never been fresher, more
self-critical, more liquid, queer, current, and liberatory are unsurpris-
ingly coincidental with the first time there is a good way for them to
sell queer performance artists, and poets: more and more gray rooms
in museums that need to be filled with audiences, that are run by peo-
ple who check how many Twitter followers a "poet" has before they
read their work. As funding for the arts and humanities is slashed,

while gentrification eviscerates the cultures of the Lower East Side and Brooklyn, museums pick from the rubble to integrate whatever pops best into these emerging gray room spaces—where experimental performance, dance, poetry, and film can finally be ossified into a total commodity. Museums heart poetry, yes, and queers. But even if museums and galleries become the only institutions left that will still throw us a measly check for a performance, reading, or screening— that doesn't mean we have to heart them back. And this refusal of loving devotion and obedience is what seems to terrify these technocrats most. Though, in the end, anything can and will be forgiven, if you have enough twitter follows to pack a room (btw, follow me now, and maybe, just maybe, I'll give you a nice little room in the prison house).

CPSIA information can be obtained at www.ICGtesting.com
Printed in the USA
BVOW08s1423250515

401683BV00001B/1/P